IMAGES
*of America*

# THE CLE ELUM
# FIRE OF 1918

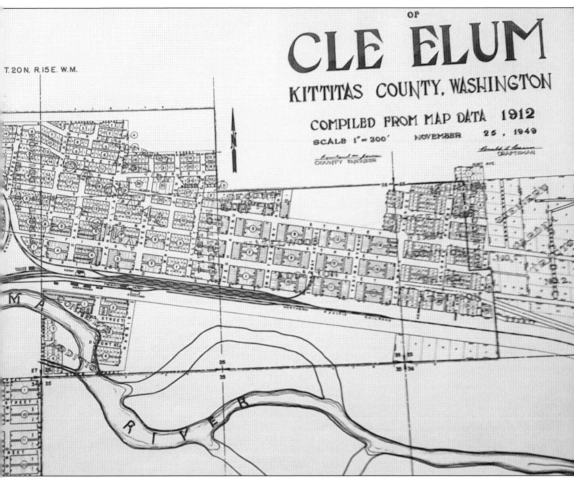

T.20N. R.15E. W.M.

## OF
# CLE ELUM
## KITTITAS COUNTY, WASHINGTON
### COMPILED FROM MAP DATA 1912
SCALE 1"=300'     NOVEMBER   25, 1949

This 1912 plat shows the scope of the town, including the swift water of the Yakima River, the rail yards, and the location of South Cle Elum. Walter J. Reed's original town plat forms the west side of Cle Elum; Thomas Gamble's Hazelwood plat lies to the east. (Washington State Archives, Central Regional Branch.)

**ON THE COVER:** A cloud of smoke billows over Cle Elum in this photograph from June 25, 1918. The photographer is unknown, but the photograph comes courtesy of Frederick Krueger. (Central Washington University Archives and Special Collections.)

IMAGES
*of America*

# THE CLE ELUM
# FIRE OF 1918

Roberta R. Newland
and John Newland-Thompson

ARCADIA
PUBLISHING

Copyright © 2018 by Roberta R. Newland and John Newland-Thompson
ISBN 978-1-4671-2878-0

Published by Arcadia Publishing
Charleston, South Carolina

Printed in the United States of America

Library of Congress Control Number: 2017957485

For all general information, please contact Arcadia Publishing:
Telephone 843-853-2070
Fax 843-853-0044
E-mail sales@arcadiapublishing.com
For customer service and orders:
Toll-Free 1-888-313-2665

Visit us on the Internet at www.arcadiapublishing.com

*To the memories of Frank and Rosina Cava of Italy and Cle Elum; John
and Gloria Cava Newland; Gail Schwartz; and Everett Thompson*

# CONTENTS

# ACKNOWLEDGMENTS

To a great degree, we can only take credit for compiling the story of Cle Elum and its fire. We are sincerely grateful to the individuals and institutions listed below for their assistance. Abbreviations for photograph credits are in parentheses following the names of the sources.

First, we must thank Frederick Krueger, retired teacher and crack historian, who spent many years, along with his students, collecting interviews and photographs of people, places, and events in the Upper County. This book would not exist without his body of work, help, and goodwill. He is a genuine treasure. Many of his photographs live at Central Washington University.

For their gracious help, we thank Brigid Clift and her staff at the Washington State Archives, Central Regional Branch, in Ellensburg, Washington (WSA); the staff of the Central Washington University Archives and Special Collections (CWU); Regina Tipton-Llamas and Judy Neslund at the Ellensburg Public Library (EPL); and the Northern Kittitas County Historical Society officers, past and present, in the persons of Lyn Derrick and Charlene and Gerald Kauzlarich, who were most generous with their photographs (NKCHS). Special thanks go to Charlene for granting us access to photographs from the Telephone Museum; Terry Hamberg at the *Northern Kittitas County Tribune* and her staff, along with Buddy Davis, the resident cat and HR director (NKCT); and Sadie Thayer at the Kittitas County Museum in Ellensburg. Photographs taken by the authors or from the authors' collection are indicated by (RRN).

Thanks are extended to "Mama" Joyce Ballard, Pete Horish, Lorraine "Poochie" Lievero, "Lucky Luciano" of the Cle Elum Telephone Museum, and Annette Ackerson for stories, leads, and good company. Thank you, County Coroner Nick Henderson, who, along with Suncadia's Steve Talerico, attempted to find the elusive Casland safe. Gratitude goes to every merchant we spoke to in Cle Elum, who have all been so kind and willing to help us.

Roberta and John give heartfelt thanks and love to their wonderful and supportive family: Duncan, John Cava, John Jacob, Paul, and Ali. To the Arcadia team, which has been so helpful and responsive, thank you so much. You have been a treat to work with.

# INTRODUCTION

The story of the westward migration and settlement of the United States is a long, fascinating, and varied one. A sense of adventure and a hankering for new experiences and new vistas have been facets of the American psyche from the beginning of European immigration and the conquering of a large part of a continent, morally checkered though it was. After all, questing for riches, the desire for freedom of one kind or another, the hope of a better life—these were the forces that drove people in the earliest of times to cross the seas and leave the known world behind. The westward migration across what would become the 48 contiguous states, including the waves of immigration in the latter part of the 19th century and the first decades of the 20th, was a natural result of the same psychological mechanisms.

The discovery of rich ranchlands brought about the establishment of Ellensburg, Washington, during the mid-19th century. When gold was discovered in Upper Kittitas County, along with rich seams of coal, the area west of Ellensburg (present-day Liberty, Cle Elum, Roslyn, and Ronald) saw its first settlers. In the 1880s, Walter J. Reed and Thomas Gamble both staked claims in Cle Elum, the special claims Civil War veterans could obtain under the Homestead Act.

Less than 10 years later, at statehood in 1889, Cle Elum had fewer than 400 residents, and soon after, it survived its first major fire in 1891. While *The Illustrated History of Klickitat, Yakima and Kittitas Counties* (Interstate Publishing Company, 1904) states that a forest fire swept into town, it appears that someone pulled the wool over the eyes of the writer of that book. In reality, little Charles Stafford, possibly along with a cousin, was playing with matches in the attic of his father's general store. His father, Theron Stafford, served as the town's first doctor and dentist, as well as pharmacist, the profession for which he was formally trained; the store stood on the southwest corner of First Street and Pennsylvania Avenue, later the site of the Northwest Improvement Company. The result of Charlie's adventure with matches was a conflagration that burned down a whole block—much of the existing business district. Charles Stafford grew up to become Dr. Stafford, performing various medical services as needed and delivering many Cle Elum babies over the course of his career.

And many babies there were. Cle Elum was loath to describe itself as a boomtown, claiming that the population rose steadily from 762 in 1900 to 2,749 in 1910, the all-time population high for this town. A tabulation of the census of 1910, Ward 1, reveals the following (all but the last line refer to both children and adults): 315 people were born in the United States; 728 were immigrants from Italy, the Austro-Hungarian Empire, the Russian Empire, and elsewhere in Europe; and fully 269 were children under the age of 18 born to two immigrant parents.

That Cle Elum became a microcosm of the American experience was taken for granted by its residents. Ethnic clubs abounded, as did ethnic slurs and ribbing. The Bagna Cauda Festival goes on to this day, as does the annual Croatian luncheon. And there was nothing incongruous about Pricco's bakery (later Osmonovich's) making delicious *povetica*, a central European rolled walnut bread (and pronounce pro-VEE-titsa in Cle Elum), alongside *torchetti* (or *torcetti*), an Italian pretzel-shaped pastry. Not only is povetica pronounced differently in Cle Elum, but peonies are not PEE-o-knees, they are pee-OH-knees (rhyming with *spumonis*), another tip of the hat to Italian influences.

Of course, when the fire of June 25, 1918, broke out, rushing east up First Street and then blowing north and east down Second and Third Streets, it cared not a bit about the ethnic origins of the people living or working in the buildings it charred. However, the reality is that the eastern end of Cle Elum brimmed with miners' shacks without a sewer system—a ghetto of sorts in a small western town. Census information and anecdotal evidence bring to light houses with outbuildings: a family of six Russian Polish immigrants, for example, who rented out their barn or shed to four boarders. Often, the boarders were of the same national origin, but not always. The east end of Cle Elum was more densely populated than the more affluent west end, and when the homes went up in flames like tinder, 1,800 people found themselves homeless.

What, exactly, was lost when Cle Elum burned in 1918? The Cle Elum *Echo*'s reporting of June 28, 1918, the first issue after the blaze, lists the following in a summary headline before a long and thorough article:

> Burned Area Covers Twenty-nine City Blocks or 70 Acres in Extent and Embraces Many Business Block—Spread Four-Fifths of a Mile Eastward from Pennsylvania Avenue Before Being Held—Swath from Two to Three Blocks Wide—Thirty-six Business Concerns Lost. Miller & Short Sawmill and Yards, Three Churches, One Small School Building and 205 Residence Houses.

Those 1,800 people left homeless comprised roughly 65 percent of the town's total population— and would be all but a few of today's population. Since the sawmill had burned, there was a shortage of lumber. The patriotic citizens had invested in Liberty bonds because World War I still raged, so cash was short. Tent cities sprang up at the west and east ends of town, and aid came in the form of Red Cross supplies such as the blankets distributed out of the old Cle Elum High School, as well as monetary and material aid from across the Northwest.

Miraculously, not a single life was lost.

The city rebuilt; the populace went about the business of recovering. Some talked about the fire; some did not; some waited decades to say that it had been bad. Not everyone stayed in Cle Elum: in 1920, the population was roughly 100 less than the total from the 1910 census. But by 1921, winter sports and the building of one of the earliest ski jumps in the area signaled vibrant high spirits and a desire to play outside, for life to go on, to improve, and to be celebrated—a different manifestation of pioneer spirit—in a town that had literally risen from the ashes.

Today, Cle Elum's population hovers around the 1,800 mark. It has lost not only around a third of its population but also its main sources of income. Coal mining tapered off after the 1930s, ending definitively in the 1960s. Logging has also greatly decreased. Freight trains still speed by, whistles blowing, but none stop, and the train depot in Cle Elum is gone, along with the Northern Pacific and its various spur lines. Traces of the Milwaukee Road in South Cle Elum remain, a veritable archaeological site, the steel rails removed. Visitors can see the foundations of the roundhouse and ride bikes along the railbed. Snoqualmie Pass, to the west by about 30 miles, did not remain open in the winters until the 1940s. The Sunset Highway (Highway 10), which crossed the pass, became Interstate 90, and in the early 1970s, I-90 bypassed Cle Elum completely.

Real life has not bypassed this small town, although so many things have happened in its history that could have laid it low or made it give up. The things that matter—the weddings, the births, the festivals, the pancake breakfasts at the Eagles aerie, the friendships, the butcher shops with fresh, local meat and house-made sausages, the bakery—all continue to make Cle Elum what it is and always has been: a small town in a small valley in the eastern foothills of the Cascades, a small town that perseveres, that holds its traditions close, a place where people still know the names of the early families and the business of their neighbors. The pace is slower here than in cities, and there is a rare sense of simplicity. This is still a town of storytellers, of people who work with their hands, of third- and fourth-generation Cle Elumites who know where to find morels, chanterelles, and boletus mushrooms but who will not divulge their secret spots.

And on winters' days, that dark, identifiable aroma of coal smoke still lends a tang to the air.

# One

# BEFORE THE FIRE

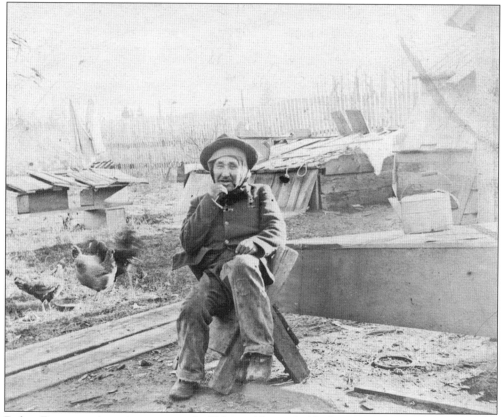

Before European Americans came, the Yakama Nation held what is now Kittitas County as its own, with settlements, potlatches, and celebrations in the Ellensburg area. The Upper County held seasonal settlements and meeting grounds. Here, in an undated photograph, Indian Pete, a member of the Kittitas Band of the Yakamas, is pictured. (NKCHS.)

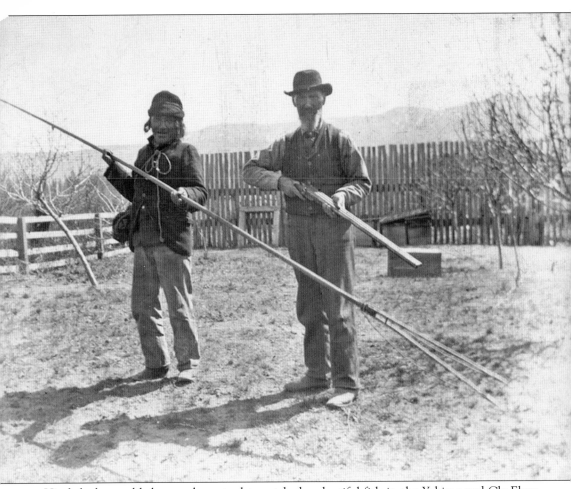

His forked spear likely served as a tool to catch the plentiful fish in the Yakima and Cle Elum Rivers. The Kittitas Band had no permanent villages in the Upper County because of its harsh winters, but tribal members frequented the area before snowfall, fishing, hunting, and gathering wild berries and mushrooms. (NKCHS.)

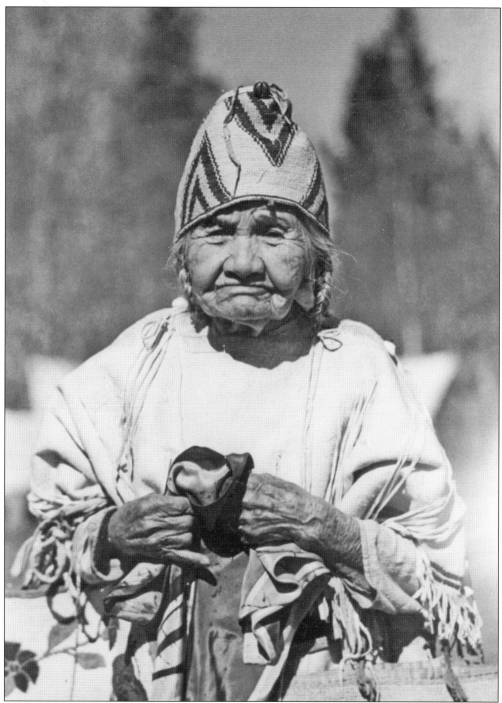

Indian John, well known for his kindness to settlers, had a daughter, Lucy, who lived to the age of 100. She wears full Kittitas Band regalia in this photograph. Her home was between Thorp and Cle Elum on what is now officially called Indian John Hill. (EPL.)

The settlement of Kittitas County by European Americans began with Catholic missions, followed by Robber's Roost at the future site of Third Avenue and Main Street in Ellensburg. Robber's Roost later became Shoudy's Trading Post. Rich ranchland and treaties with Native American tribes spurred development. The trading post burned in Ellensburg's fire of 1889. (EPL.)

Prospectors struck gold in Liberty, bringing on a gold rush of modest proportions. Settlement of the Upper County began partially as a result of this gold rush. Visitors can still pan for gold in Liberty, where a permanent population of 10 puts it into the category of a living ghost town. (NKCHS.)

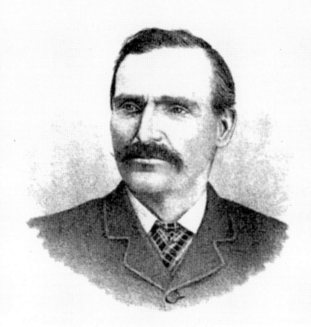

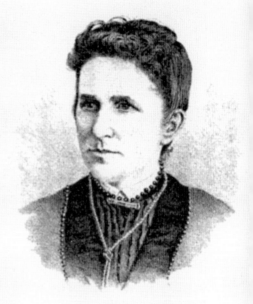

WALTER J. REED,
CLE-ELLUM, W.T.

MRS. BARBARA REED,
CLE-ELLUM, W.T.

Pictured here are Walter J. and Barbara Steiner Reed. Walter Reed and Thomas Gamble, friends from childhood and both Civil War veterans, filed preemption claims in what would become Cle Elum in 1883. The name derives from the dialect of the Kittitas Band of the Yakama Nation and means "swift water." (RRN.)

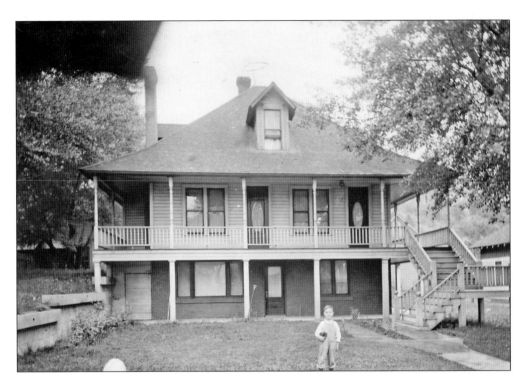

Walter J. and Barbara Steiner Reed built a home on Third Street around 1893; it was the first home with running water. In 1919, the home was sold and the Reeds returned to Yakima. The house was converted into apartments and operated until 1976, when it changed ownership. It burned in the early 1980s. (Both, RRN.)

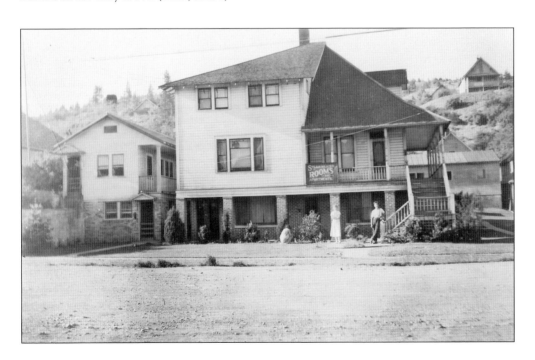

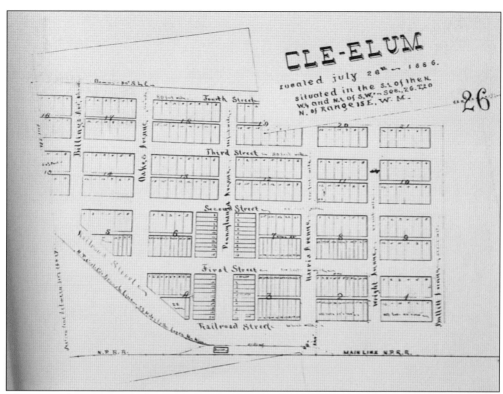

The original town plat and its first addition were filed by Walter Reed and comprise the majority of the business and residential districts on the west end of town. (Both, WSA.)

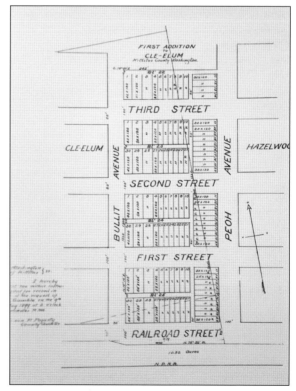

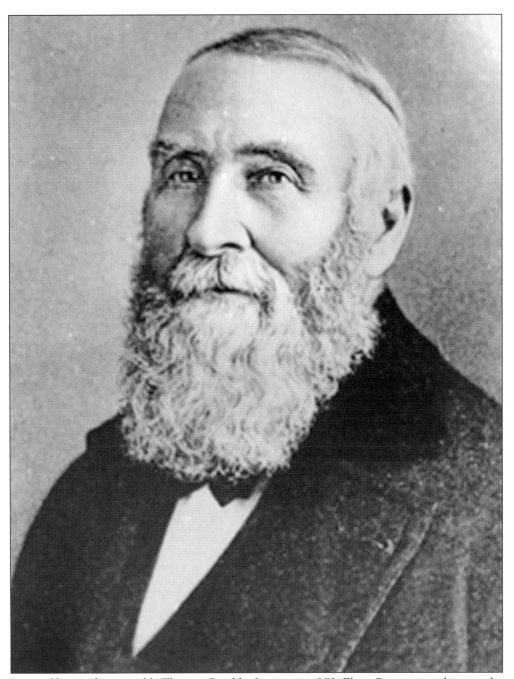

Pictured here is the venerable Thomas Gamble, first mayor of Cle Elum. Preemption claims under the Homestead Act allowed veterans to deduct their service time from the five years required to prove a claim for ownership. This clause in the Homestead Act played an important role in westward migration. (NKCHS.)

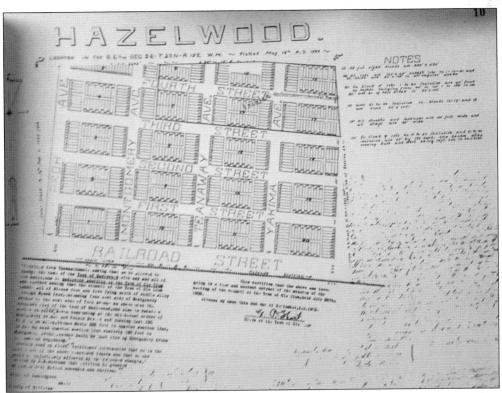

Thomas Gamble platted the eastern half of Cle Elum, calling it the Hazelwood Addition. When coal was discovered at this site, 30 acres were dedicated to the establishment of the Independent Mine. The First Addition plat shows the unusual blocks with narrow horizontal and vertical lots making up the miners' homes bisected by alleyways. While Hazelwood is referred to as a town, it is not separate from the rest of Cle Elum, and the fact that it was once known as Hazelwood seems forgotten by Cle Elum residents in 2017. (Both, WSA.)

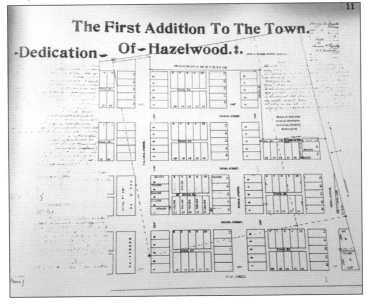

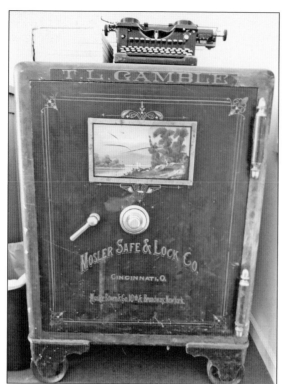

In 2017, Gamble's safe can be found at the *Northern Kittitas County Tribune* office—with a manual typewriter on top. (RRN.)

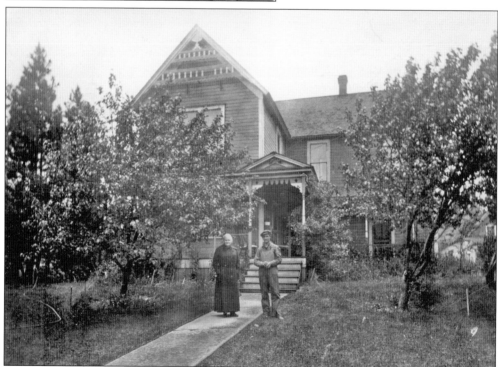

Gamble's residence was at 603 East Third Street. Here, Margaret Gamble and her caretaker stand in front of the home around 1920. (NKCHS.)

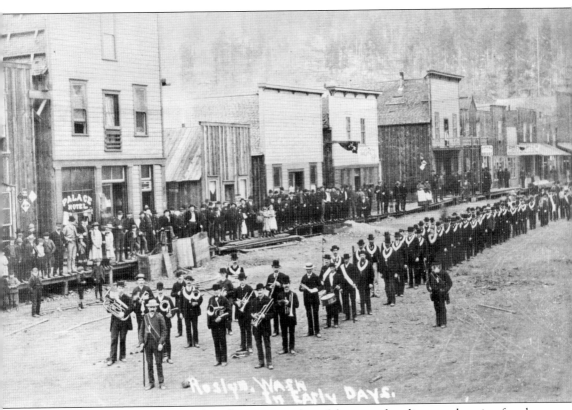

Two years after Reed staked his claim, he was a member of the party that discovered a vein of coal in what would become Roslyn, three miles west of Cle Elum. Coal production started in 1886; the Northern Pacific Railroad needed coal to run its engines. The Northwest Improvement Company was, at that time, a Northern Pacific subsidiary, and Roslyn, a company town, is pictured here in an undated photograph. (NKCHS.)

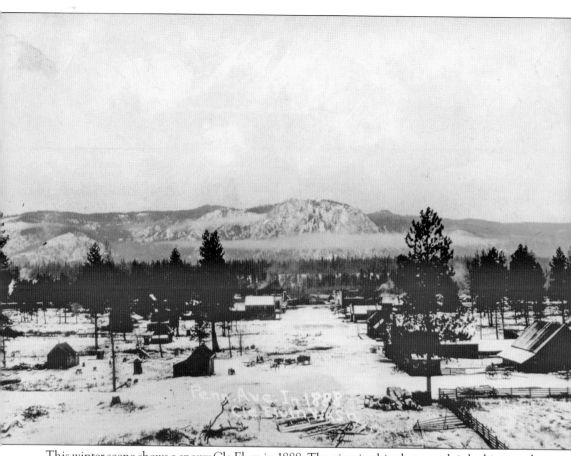

This winter scene shows a snowy Cle Elum in 1888. The view in this photograph is looking south on Pennsylvania Avenue toward Peoh Point. The white roof near the center belongs to an early business and stands at about the location where the fire would start in 1918. (NKCHS.)

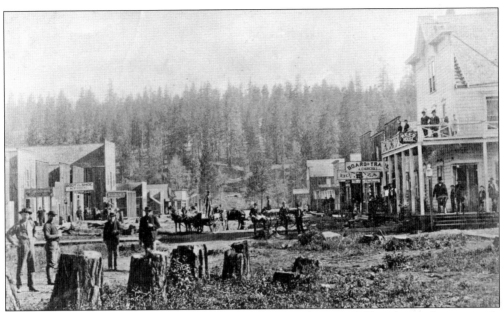

Cle Elum grew along the triple-wide streets decreed by Barbara Reed. Travelers and new arrivals who needed a place to stay had options for accommodation, among them the Reed House, seen at the right of the picture. This photograph dates to 1889, the year Washington Territory became a state. (NKCHS.)

First Street was graded and paved early in Cle Elum's history, and sidewalks replaced boardwalks in places. However, the homes at the east end of town had neither paved streets nor sewers until after the fire. (CWU.)

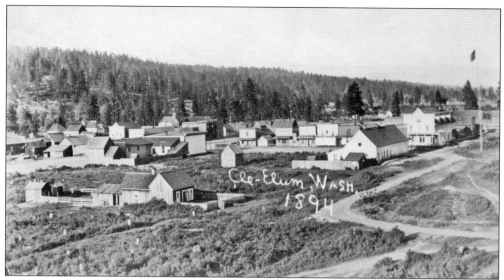

The year is 1894, and Washington has been a state for five years. With a view looking to the northeast from Hospital Hill, this photograph shows a dirt road on the right where railroad tracks would soon be. The white structure with the pointed roofline on the southeast corner of Pennsylvania Avenue and Railroad Street is the Reed House. It survived the 1891 fire that destroyed most of the business district, so this photograph shows a town already rebuilt once. (NKCHS.)

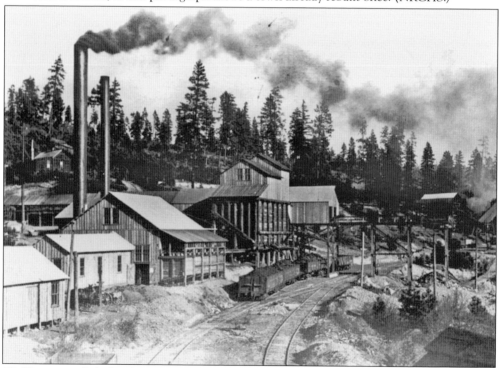

Cle Elum struggled after the fire of 1891, but Thomas Gamble's discovery of coal in 1894 changed everything. The Independent Mine was subsequently established near Cle Elum's eastern boundaries. Now Cle Elum was more than a transit point; it produced its own coal. The Northwest Improvement Company moved into Cle Elum, though Cle Elum was never strictly a company town. (CWU.)

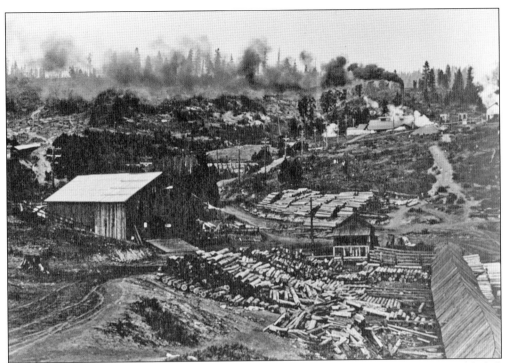

In 1908, disaster struck Cle Elum again when the powder house at one of the mines exploded. Nine people were killed, and the newspaper reported that body parts were strewn over a half-mile area. This 1917 photograph of the Number 7 Mine provides a view into that world. (CWU.)

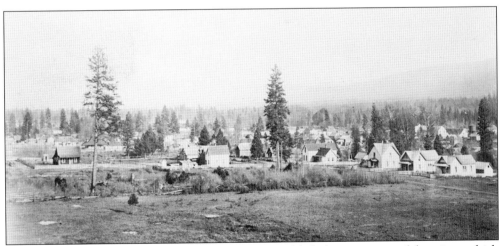

This view of the east end of Cle Elum, taken in 1905, is likely from near one of the mines, which were mainly to the north of town. (CWU.)

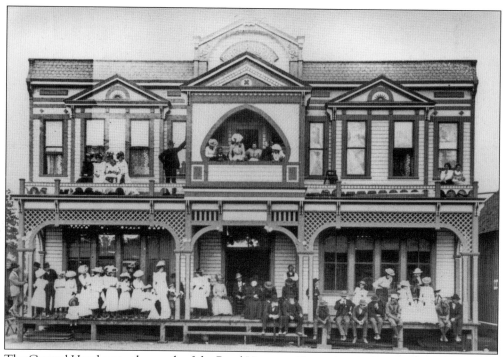

The Central Hotel sat to the north of the Reed House on Pennsylvania Avenue, next door to the Cascade House and Hotel Travelers (after its construction around 1919) and around the corner from the Rose Hotel. The second-story porches seen in this photograph were later outlawed and dismantled; the snow load often proved great enough to collapse them. (NKCHS.)

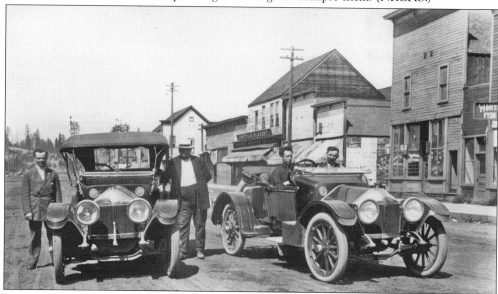

For early motorists, the creation and maintenance of roads passable throughout the year was a major goal. In 1915, the Good Roads Boosters passed through Cle Elum bound for Seattle across Snoqualmie Pass, via Highway 10, which opened that year. After the 1918 fire, the fact that an official from the west side of the state drove across the pass during the night of June 25 was worthy of an article in the *Echo*. (NKCHS.)

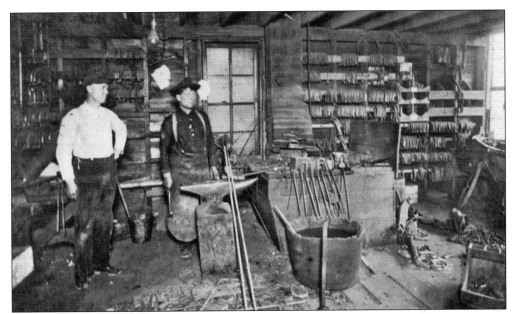

Early towns needed blacksmiths to forge metal, and Cle Elum was no exception. Several smithies like this one can be found in the 1915–1916 *Polk Directory*. Directories and phone books were not printed every year, as they depended on the city raising a subscription fund for the printing. Cle Elum occupies part of the back of the Ellensburg directory, along with the other small towns in the county. The next directory would be issued for 1919–1920. (CWU.)

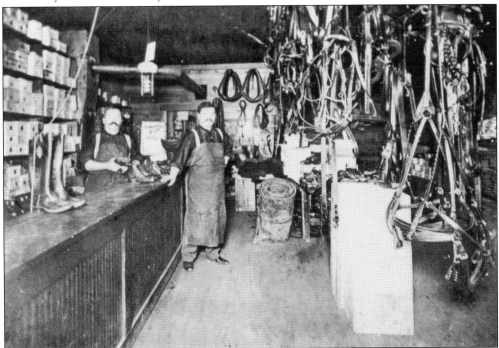

Several hardware stores operated in Cle Elum, and two were lost in the fire of 1918. Hardware stores sold durable goods and tools, articles one needed daily. In this early photograph, harnesses are at the back of the shop and boots are on the counter. (CWU.)

Joe Schober, an Austrian immigrant, established the Hazelwood Grocery Store, which started as a bakery in 1902. The photograph below shows the interior of the store before its destruction in the fire of 1918. Schober rebuilt, and he and his family operated it for 67 years. The family donated its extensive photograph collection to the Upper County, and many photographs in this book come from the Schober Collection. (Left, EPL; below, CWU.)

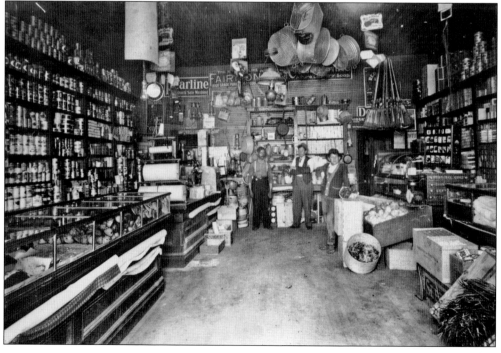

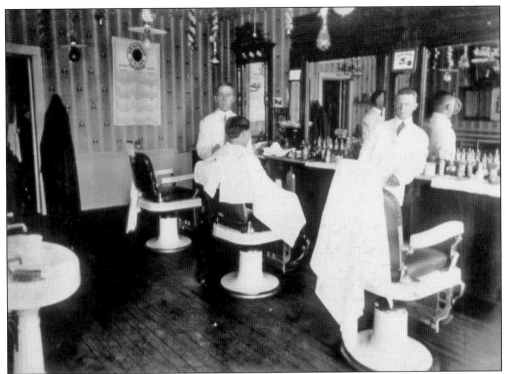

Men have fond memories of the care they received at barbershops; this would have been especially true in a coal town, where not everyone had running water. Warm towels, straight razors, and bay rum—the barbershop rituals have largely disappeared. Above is the interior of one of Cle Elum's barbershops; below is Frank Cava, whose original shop was destroyed in the 1918 fire. He stands in his new First Street shop in the mid-1930s. (Above, NKCHS; below, RRN.)

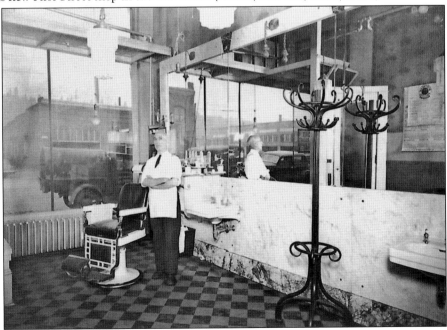

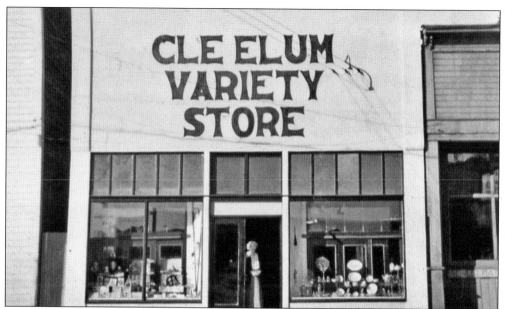

The Cle Elum Variety Store does not appear in either the 1915–1916 or the 1919–1920 *Polk Directory*, and this undated photograph gives few clues. The long skirt on the woman suggests a time prior to 1930. The items in the window are more womanly goods than those seen in the hardware store: plates, glassware, and possibly sewing patterns on the left. (NKCHS.)

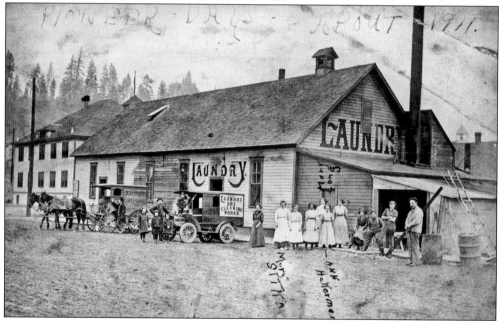

Imagine doing laundry in a tub of boiling water heated on a cookstove, hauling it out with a hook, putting it through a wringer, drying it in the sun, and then ironing it with flatirons heated on the stove. In Cle Elum, one could also take it to the steam laundry on Second Street. This building, directly to the north of the Cle Elum State Bank and across the street to the south of the Cle Elum School, amazingly survived the fire of 1918. This photograph dates to 1911, during which time C.S. Enright was the proprietor. (NKCHS.)

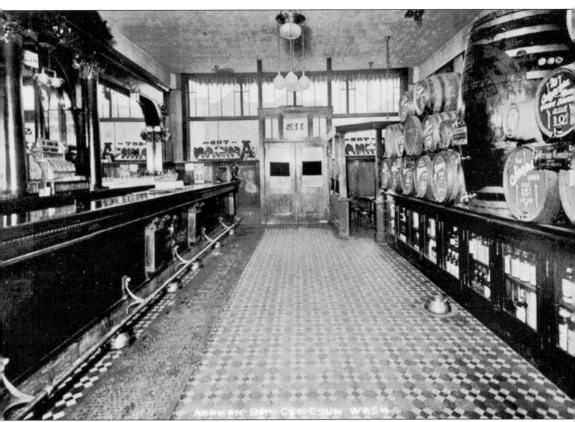

In its early days, Cle Elum catered largely to men who worked in the mines or on the railroad. Saloons and bars abounded. The Ashman Bar occupied the Kinney Building, which survived the fire and which, once refurbished, was home to the Autorest Café. Proprietor Bruce Ashman was a lightweight boxer and wrestler as well as a Cle Elum entrepreneur. Old-timers have reported that the ornate, imported bar, which also escaped the fire, along with the back booths, was ultimately sold to someone in Sumner, Washington, when the Autorest closed in 1975. (NKCHS.)

The Depot Bar, shown at left in its glory days, stood on Railroad Street. Below, around 1930, the bar seems more run-down and seedy. It was demolished in the 1970s and the Napa Auto Parts store is in its location in 2017. Railroad Street was not taken by the fire of 1918, but the street was notorious for its bars and, most famously, brothels. Walking down Railroad Street today would be much less colorful. Not only have those businesses closed down, but the vast majority of the older buildings have disappeared as well. (Left, NKCHS; below, CWU.)

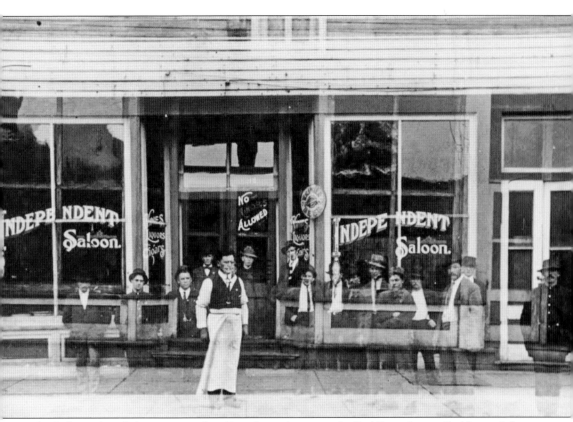

The Independent Saloon operated on First Street between the Red Front Livery Stables and the First National Bank. All on a square block in 1910, a man could get a shower, a shave and a haircut, have a few drinks, close a bank account, and ride out of town. This photograph dates to 1910 and is possibly a trick photograph, with the customers in front of the Independent superimposed. The result is ghostly. (CWU.)

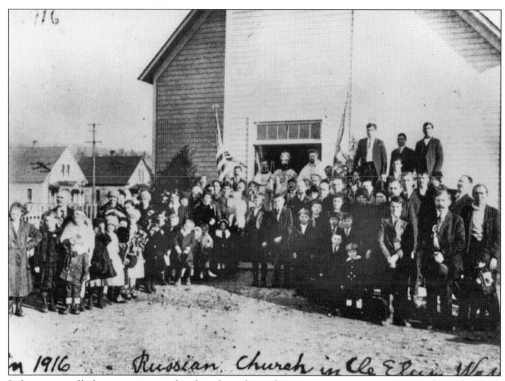

1916 — Russian Church in Cle Elum Wa.

Life was not all about mining and railroads and watching a town grow. Immigrants brought their faith traditions with them, and a variety of faiths were practiced in Cle Elum. Enough people had emigrated from the Russian Empire that a Russian Orthodox church had its own building. Unfortunately, it was lost in the fire of 1918. After that, services took place in private homes, with a circuit priest brought in for special occasions. (Both, NKCHS.)

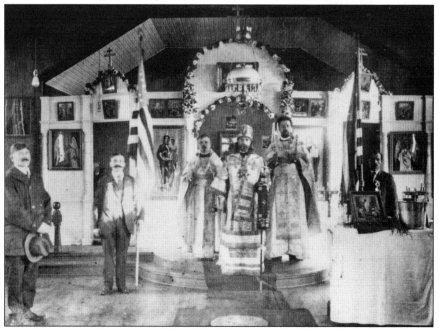

Many Catholics came to Cle Elum from many different countries. They worshipped at the Church of St. John the Baptist, which burned in the fire. It was rebuilt on West Second Street, a full block from the westernmost point of destruction. The Presbyterian church also burned; it was not rebuilt and eventually fused with the Baptist church. (CWU.)

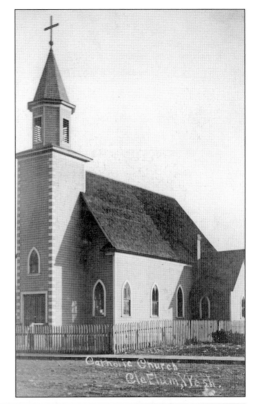

The date and exact location of this photograph are unknown, but the flag is Italian. Ethnic clubs, lodges, and festivals have always been popular in Cle Elum, cementing communities with a shared heritage, language, and food. Picnics and simple outings, as well as more formal gatherings, were and are the norm. (NKCHS.)

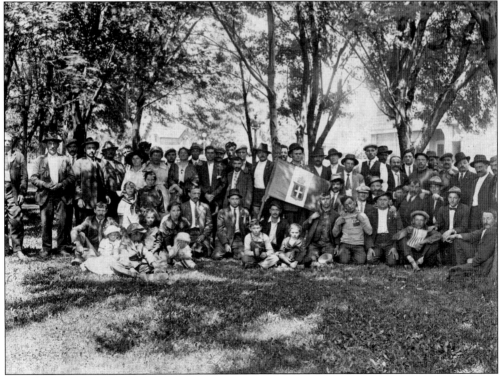

Bocce ball, *boules*, *pétanque*, lawn bowling—whatever name it goes by, the game is popular in many cultures. This undated photograph appears to show a group of Italian immigrants on the east end of town before the fire, ready to enjoy arguing about the distances between the bocce balls. (NKCHS.)

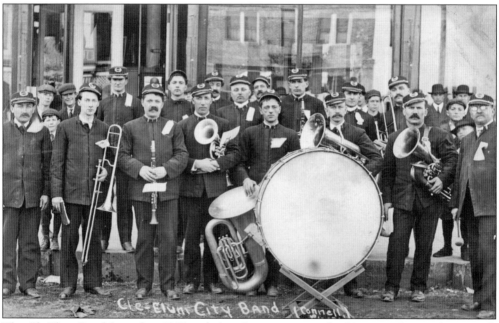

The Cle Elum Band formed in 1902 and played at civic events for 50 years. The conductor with the longest tenure, James Bertello, was simply known as "Maestro." Cle Elum loved its music and, while it may be stereotypical, the many Italians favored opera; when Enrico Caruso performed locally, the concert sold out. (NKCHS.)

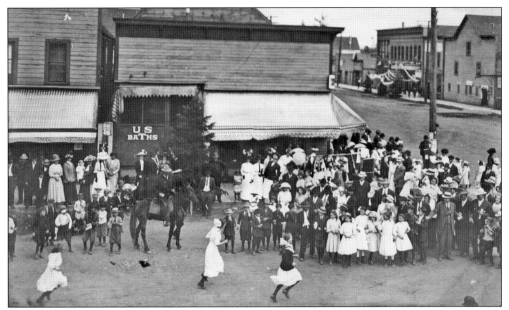

Early photographs captured the moments of the town's civic celebrations; July 4 was quite popular. Many Cle Elum immigrants became naturalized American citizens as quickly as possible and took dual pride in both their country of origin and their adopted land. Footraces were a tradition on July 4: the girls' race, the "Fat Man's Race," and the three-legged race. Here, before the fire, is the girls' race down Pennsylvania Avenue where it intersects with First Street. (NKCHS.)

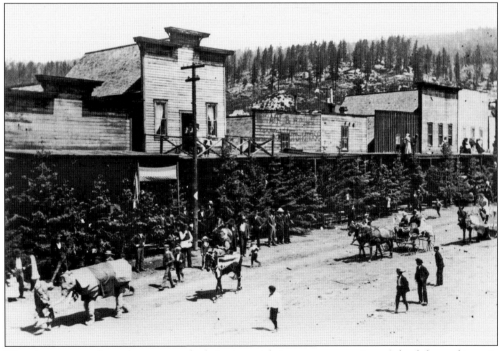

The circus came through town yearly, bringing with it great commotion. A backdrop of trees is set at the side of the road, and people watch from their soon-to-be-removed balconies. The year is 1901. (NKCHS.)

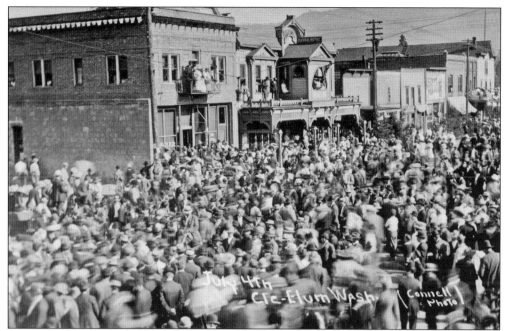

This Russell Connell photograph does not say on which July 4 it was taken, but the Cascade House, August Sasse's lodging place, dates it to before the fire. The Central Hotel stands on the right. (NKCHS.)

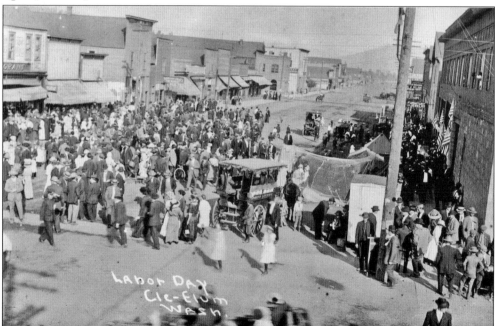

Cle Elum had a strong Northwest Improvement Company presence. Union organizing, labor struggles, and strikes (sometimes hard-fought and bitter) took place in Cle Elum, Roslyn, and Ronald. Labor Day, then, was more than a Monday in September. It was a day for celebration and standing up for solidarity. At the intersection of Pennsylvania Avenue and First Street, once again the pre-fire wooden buildings serve as a backdrop for this photograph. (NKCHS.)

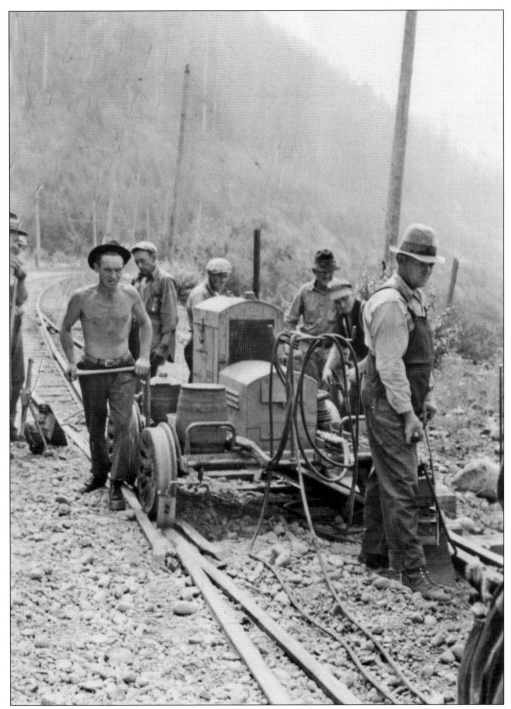

No look back at Cle Elum is complete without addressing the railroads. The Northern Pacific out of Cle Elum and the Milwaukee Road out of South Cle Elum were the backbones of these communities, carrying passengers, coal, lumber, and in time of war, troops. But first the tracks had to be laid. Here, in an undated photograph, the tamping machine compacts the earth in preparation. (NKCHS.)

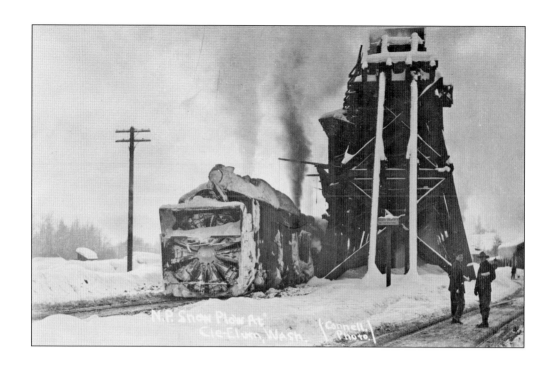

When it snowed heavily through the Cascade Mountains and in Cle Elum, as happened often, the tracks themselves had to be cleared. Special snowplow trains operated, often at night when rail traffic was at its lowest, to make the railroad passable. This early view shows not only the rotary snowplow on the front of the train but also the coal bunker at the Cle Elum rail yard. Coal of various grades was loaded from this structure. The winter scene, photographed by Russell Connell, gives a good idea of the amount of snow during a hard winter. (Both, NKCHS.)

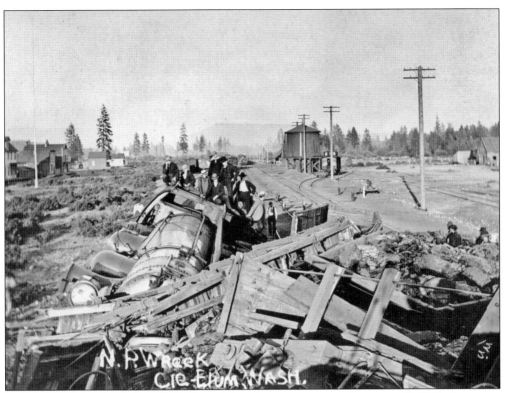

Train wrecks unfortunately did happen, and they drew spectators with cameras. By 1910, there were 13 tracks in the Cle Elum rail yard, so this photograph dates farther back than that. (NKCHS.)

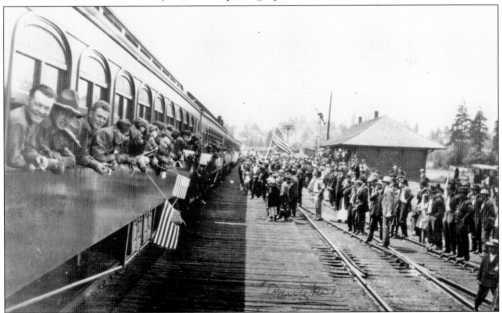

Over there the doughboys went during World War I. The Railroad Street brothels were strictly off-limits if the train made a lengthy stop in Cle Elum. Here, dreams of adventure and valor written on their faces, young men smile from a troop train. (NKCHS.)

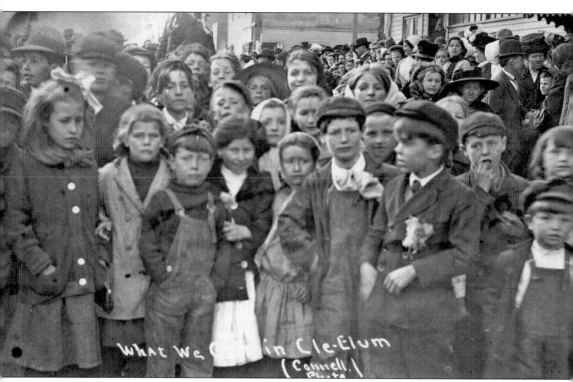

What We ( ) in Cle-Elum
(Connell. )

The stage is now set for the Great Fire of Cle Elum on June 25, 1918. It was a town of immigrants and their children. They had come from Italy, from Croatia, Serbia, and elsewhere, sometimes via other coal mining towns in the United States. Many of the children were born citizens of the United States. (NKCHS.)

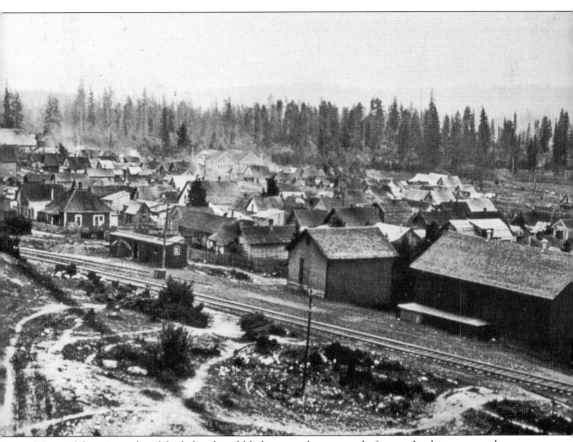

Many of the miners lived fairly hardscrabble lives on the east end of town. In this area, roads were unpaved, and there was no sewer system until after the fire of 1918. (CWU.)

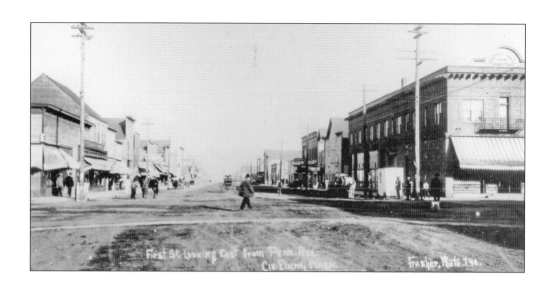

Farther west, Barbara Reed's triple-wide streets gave Cle Elum a sense of openness, almost of grandeur. Despite World War I's bloody battles, labor struggles, and the complexities associated with the "salad bowl" of the immigrant experience, the future shone as bright as a day in June. (Above, EPL; below, NKCHS.)

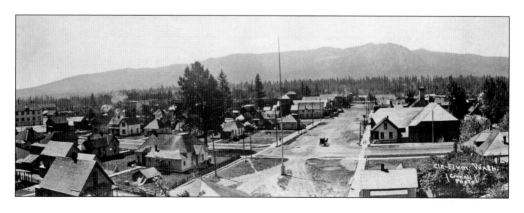

# Two

# THE GREAT FIRE
# OF CLE ELUM

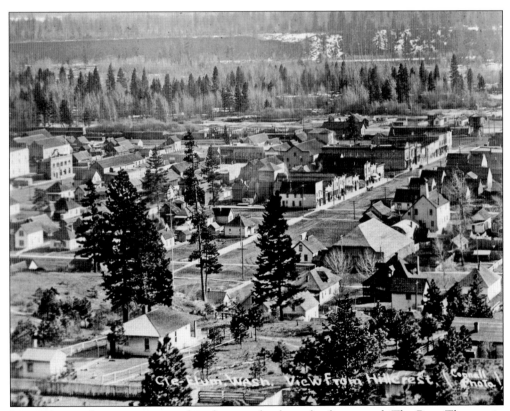

It is easy enough to pinpoint on this photograph where the fire started. The Rose Theatre, in the center of the commercial block in the middle of the photograph, was separated by a one-foot airspace from the Moss Building next door. Behind them, a driveway or partial alley flanked the buildings as it does today. In that alley, fire somehow kindled in the trash, and that was all it took. (NKCHS.)

# CLE ELUM SWEPT BY FIRI

The *Cle Elum Echo*, the weekly newspaper, operated until 1922, when it and Roslyn's *Cascade Miner* combined into the *Miner-Echo*. Because it was a daily, the *Seattle Daily Times* actually reported on the fire sooner than the *Echo*. The front page of the *Times* appears later in this chapter. Here, the headline from the *Echo*'s June 28, 1918, edition—the first after the fire—is shown. (NKCT.)

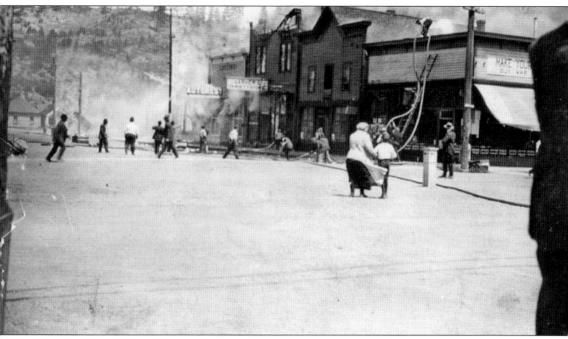

At around 1:30 p.m. on Tuesday, June 25, fire caught behind the Rose Theatre in a narrow airspace between it and the Moss Building. Trash collected at the rear, south corner of the theater, and this is doubtless where it all began. But how is unknown: a cigarette, cigar, or lit match carelessly tossed is assumed. There is some speculation that a staircase up to the second story bridged the two buildings, and a spark fell through a gap in the stairs. Notice how the woman's skirt is blowing on that windy day. (CWU.)

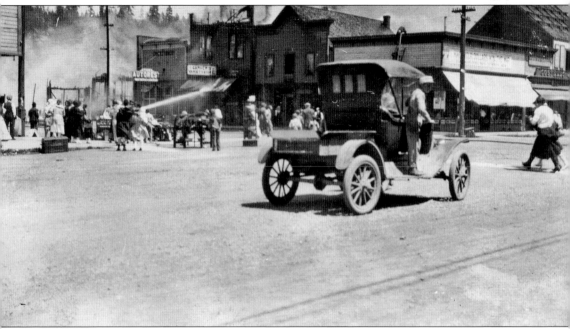

Mona Moss saw the fire from the upstairs window of the Moss Building, a rooming house and confectionery shop. She called to her mother downstairs, who phoned for help. A Mrs. Snyder and the Widow Davis also saw the early stages. The fire department received a phone call and, since it was on the northwest corner of Pennsylvania Avenue and Second Street as it is today, arrived quickly at the scene. (CWU.)

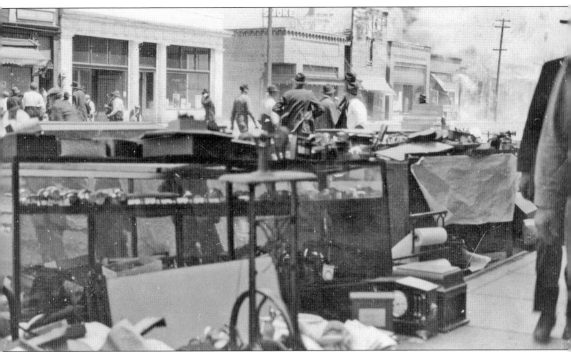

Along with a railroad man, the manager of the Rose Theatre, Walter Steele, ran from his home a block away and into the theater, where he found the curtain ablaze. By the time the reporter from the *Echo* arrived, the stage itself was burning. Nothing could be salvaged. The airspace between the two buildings acted as a chimney, threatening to funnel the fire across the entire block. Costello & Duffy, a men's clothing shop, had just received a shipment of goods earlier that day. The store's entire inventory was dragged across to the south side of First Street. Barbara Reed's wide streets likely provided a fire break that day, making net losses less than they might otherwise have been. (CWU.)

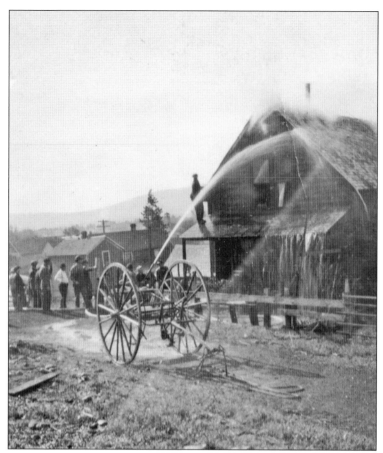

The Cle Elum Fire Department had two or three hose carts, and the town was amply supplied with fire hydrants. Nevertheless, this blaze was too much for the firefighters; their training and practice could not stop the wind, which blew east at gale force, fanning the flames. At left, a home is sprayed from a hose cart during a training exercise; and below, the fire department stands with its carts on July 4, 1915. (Both, NKCHS.)

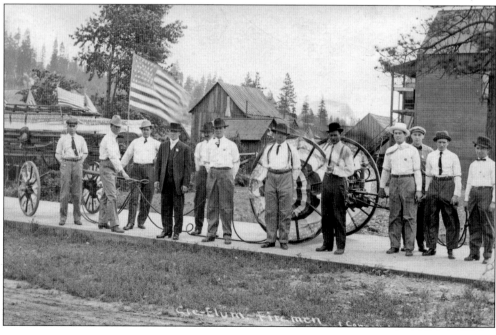

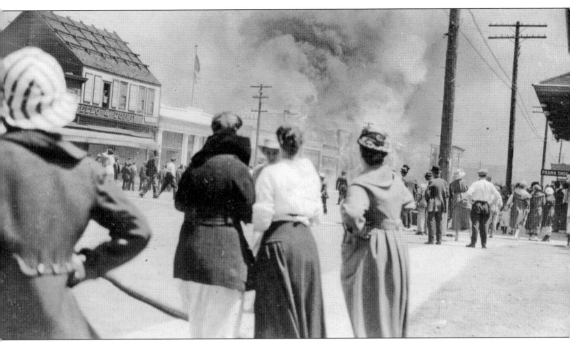

People watched, and some tried to help. The fire continued down the block, growing as it went. Someone said later that the very beginnings of the fire probably could have been put out with a normal garden hose, but that was not to be. The first fire department hose laid to fight the fire actually burned on the ground before water filled it. (CWU.)

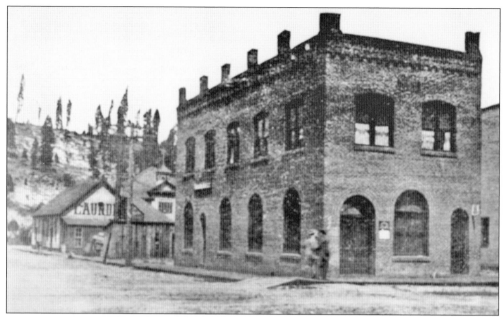

At Harris Avenue, one block east of Pennsylvania Avenue, the fire easily jumped the street, driven by the wind. The three buildings pictured above in 1917 actually survived the fire. The steam laundry survived out of sheer luck. The Cle Elum State Bank survived because "Bat" Masterson, at left, seeing smoke, had ridden into town from his ranch four miles east of town on horseback. He pulled out the flaming wooden window sashes, while Frank Carpenter, the bank president, and John Kashevnikov got to the water barrel on the roof and drenched the structure. At the old Cle Elum High School, Van Martin, the janitor, joined by Harold Cox, president of the class of 1918, doused sparks on the roof with regular hoses. This act did not just save the school, it probably also spared many other buildings on Second and Third Streets, as the wind had shifted, now blowing to the northeast. (Both, EPL.)

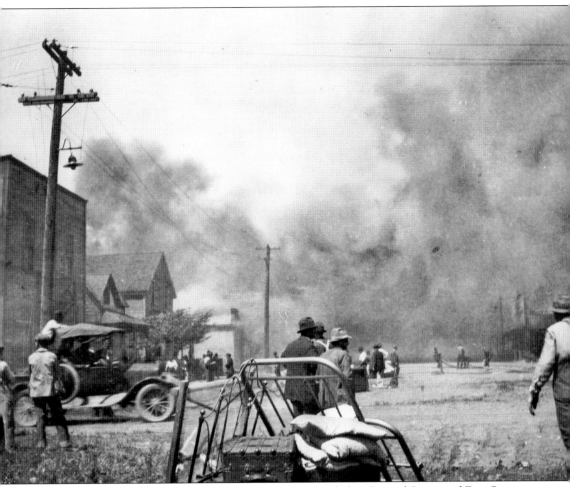

The extra-wide streets served Cle Elum well as the fire traveled up Second Street and First Street. Cle Elum had both sidewalks and boardwalks, with concrete most common on First Street. More belongings were dragged to the middle of the street to give them some chance of survival. The tree on the left side of this photograph shows the force of the wind. (CWU.)

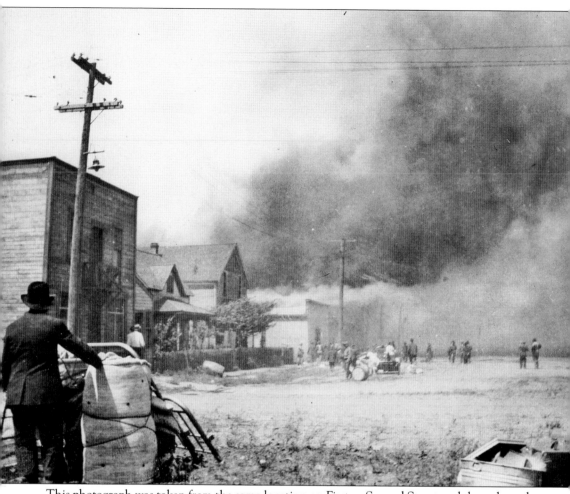

This photograph was taken from the same location on First or Second Street and shows how the smoke and fire spread to the buildings down the street. One story tells of a baby in a carriage placed in the middle of the road with the household belongings being snatched to safety as a spark caught the coverlet on the stroller. The middle of the street was the best location for treasures, but even then, their survival was in doubt. (CWU.)

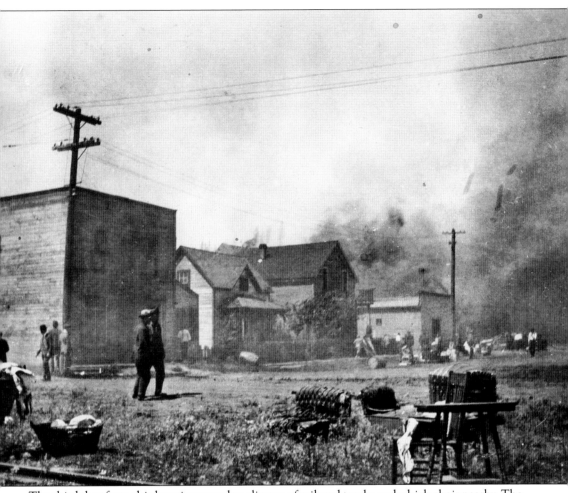

The third shot from this location reveals a glimpse of railroad tracks and a high chair nearby. The photograph might have been taken from one of two locations: along the Northern Pacific track just south of Railroad Street, with a view towards First Street, or along the spur line that ran up Teanaway Avenue to the Independent Mine. The fire jumped the spur line tracks. (CWU.)

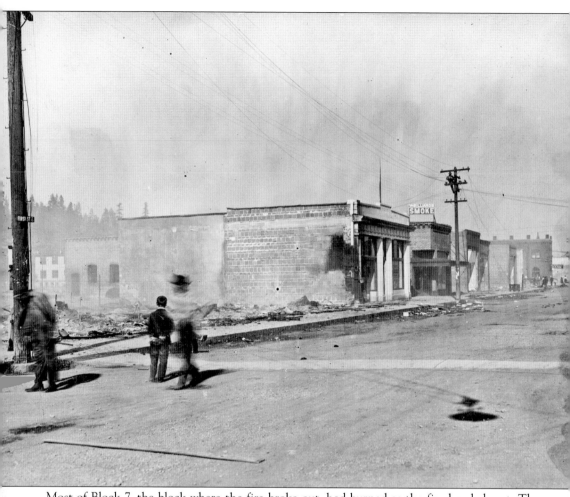

Most of Block 7, the block where the fire broke out, had burned as the fire headed east. The damaged First National Bank stands in the foreground of this photograph, and the Masonic hall can be seen at the far right. (CWU.)

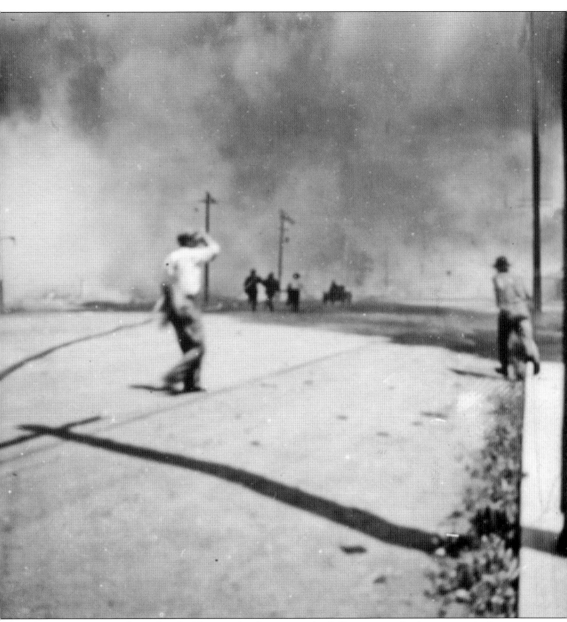

One man runs and another holds onto his hat as smoke billows towards the east end of town. A car heads eastwards. Firefighters enlisted cars to pull hoses, since they moved faster than the department's carts, which used either human or horse power. However, people whose homes stood in the direct path of the fire, if they had a car, piled what they could into it; often, these items were all that remained once the fire burned out. (NKCHS.)

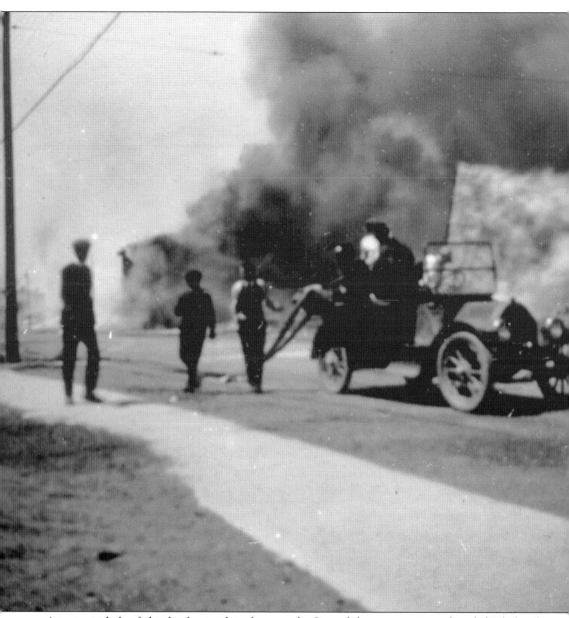

A motorist helps fight the fire in this photograph. One of these motorists enlisted the help of Phillipina Ozurka Bourke, and they raced to the east end of town, fetching black powder from the Independent Mine. They did not take such action spontaneously; the plan to dynamite came from the fire department. The intent was to destroy houses and create a firebreak. Some homeowners refused; others cooperated and saw their homes explode. The story goes that a member of the Reay family on East Third Street greeted the dynamite team on his front porch with rifle in hand, his answer an absolute no. Fortunately, since his house was on the north side of Third Street, it did not burn. The fire went where it was carried by the wind, rendering the firebreaks useless. (NKCHS.)

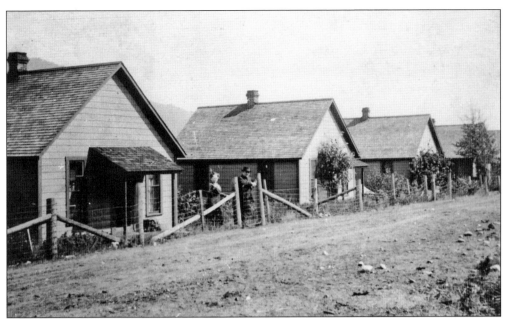

This photograph provides another glimpse of the workers' residences at the east end of Cle Elum. The dwellings were quite close together, and here the streets were narrower and unpaved. The exact location of this photograph is unknown, but it is possible that one or more of these homes was dynamited; it is certain that most of them, if not all, were destroyed. (EPL.)

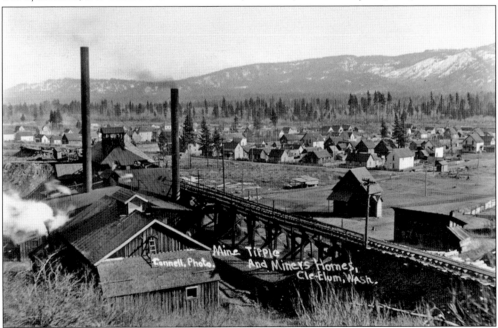

This picture of the Independent Mine is undated but provides a view of the east end of town unusual in vintage Cle Elum photographs. Russell H. Connell is the photographer responsible for this and so many other photographs of Cle Elum used in this book. His home was in the Hillcrest Addition, from which he took many photographs. The Connell family home burned in 1934. (CWU.)

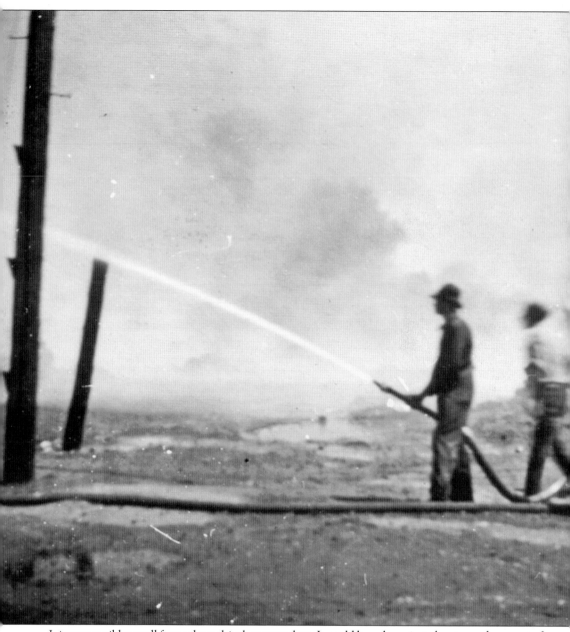

It is not possible to tell from where this shot was taken. It could have been just about anywhere east of Pennsylvania Avenue, near one of the three churches that burned, or from the building that was used as a schoolbook repository, costing the old Cle Elum High School all its textbooks. (NKCHS.)

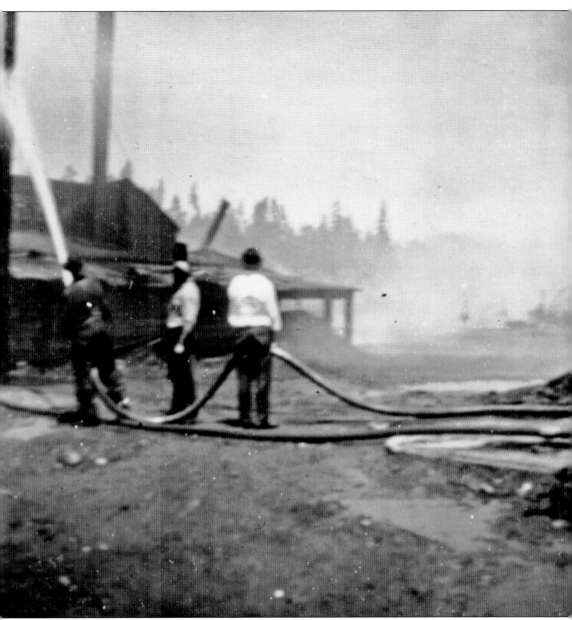

Similarly, this spot is difficult to pinpoint, but it appears to be at the east end of town, where the ridge slopes down near the Independent Mine. These are two of the many blurbs that appears in the *Echo* of June 28, 1918: "Mr. and Mrs. Melos and eight children, who lived on Second street [sic], lost clothes, bedding and furniture." "Mrs. Paulina Biagi, whose husband is suffering from asthma, is the mother of five children, two being in Europe. She completely lost everything, her home, clothing and furniture." (NKCHS.)

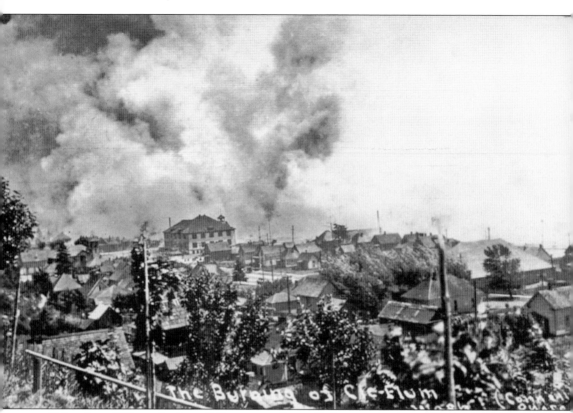

Taken from Hillcrest by Russell Harrington Connell, this may be the most iconic image of the Cle Elum fire. The old Cle Elum High School is the large building just left of center. It was at the same location as the newer brick school, built in the 1920s and serving in 2017 as condominiums. A version of the photograph was hand tinted and can be seen at the Carpenter House in its third-floor exhibit of fire photographs. (NKCHS.)

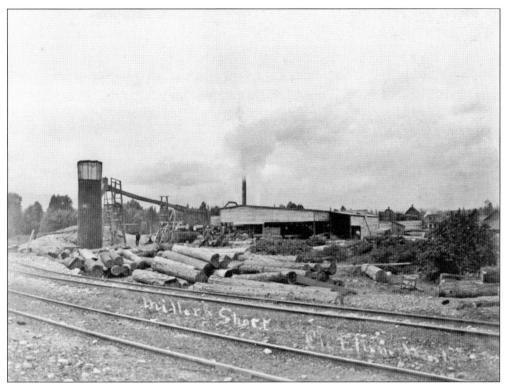

If the chimney is in actuality a smokestack, the above photograph may show the burning of the Miller & Short Sawmill and Lumberyard, also pictured below in 1915. The *Echo* reported that the yard was a total loss. This business marks the southernmost point the fire reached, close to the Northern Pacific tracks. Joe Ozbolt, who lived next to the mill, remembered cows from the immigrant households being herded across the Northern Pacific tracks and the tracks of the spur line bending like horseshoes or bananas from the heat from the fire. The memory of his family home burning and his mother's crying over that loss stayed with Ozbolt for the rest of his life. He was three years old at the time of the fire. (Both, CWU.)

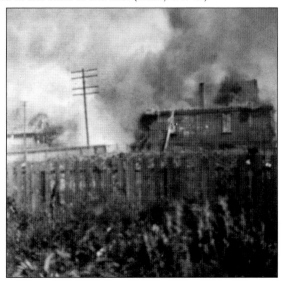

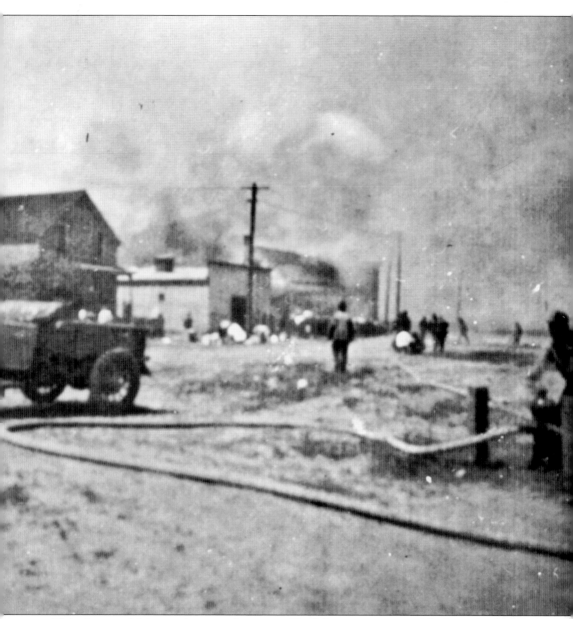

This photograph's interest lies in its depiction of firefighting in action, with hydrants in the process of opening to the hoses. The heat from the fire was so intense that windows on the south side of First Street cracked or broke, but not a single building was touched by flames to the west of Peoh Avenue on the south side of the street. (CWU.)

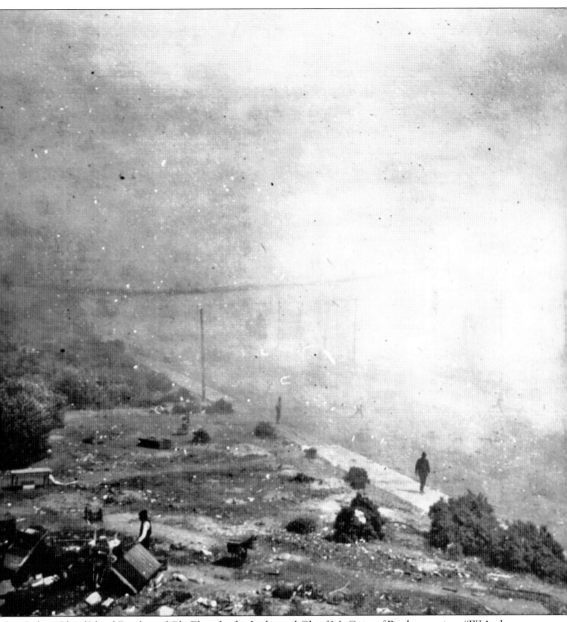

Police Chief Lloyd Bunker of Cle Elum had telephoned Chief McCain of Roslyn, saying, "We're lost but help us save what we can." Ellensburg's firefighters headed to Cle Elum by train, arriving around 2:30 in the afternoon, and attacked the eastern flank of the fire. By 4:00, the fire had stopped its advance, in part because it had come to the far east end of town, and any cinders blowing east of Columbia Avenue could be controlled before they wreaked any more havoc. The Cle Elum fire, driven by the wind, had nearly destroyed the town in two and a half hours. (CWU.)

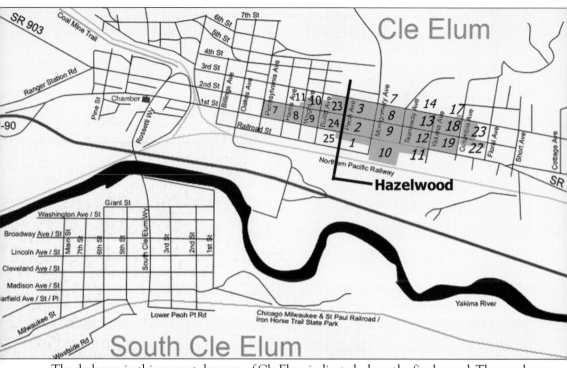

The dark area in this current-day map of Cle Elum indicated where the fire burned. The numbers in the squares indicate the block numbers according to the original town plat; those in italics signify the Hazelwood Addition. (City of Cle Elum.)

## Burned Area

Block 7, O. T.—All burned but First National Bank and Kinney building.

Block 8, O.T.—All burned but Cle Elum State Bank and Cle Elum Laundry.

The *Cle Elum Echo*'s thorough reporting allows readers the details of the burned city. "O.T." refers to the original town plat. A copy of this issue of the newspaper is available at the office of the *Northern Kittitas County Tribune* or on microfilm at the University of Washington Library. (Both, NKCT.)

Block 9, O. T.—All burned.

Block 24, O. T.—All burned.

Block 2, Hazelwood Add.—All burned.

Block 9, Hazelwood Add.—All burned.

Block 12, Hazelwood Add.—All burned but one house.

Block 19, Hazelwood Add.—All burned.

Block 22, Hazelwood Add.—All burned north of alley.

Block 23, Hazelwood Add.—All burned but one house and Hazelwood school.

Block 18, Hazelwood Add.—All burned.

Block 13, Hazelwood Add.—All burned.

Block 8, Hazelwood Add.—All burned.

Block 3, Hazelwood Add.—All burned.

Block 23, O. T.—All burned but the northwest quarter of block.

Block 10, O. T.—All burned but seven houses.

Block 11, O. T.—One building burned.

Block 17, Hazelwood Add.—Four houses burned.

Block 25, O. T.—East half north of alley burned.

Block 24, O. T.—One half burned.

Block 1, Hazelwood Add.—North half burned.

Block 10, Hazelwood Add.—All burned north of railroad.

Block 11, Hazelwood Add.—North half burned.

City hall and the fire department jointly occupied the building on the northwest corner of Second Street and Pennsylvania Avenue, kitty-corner from the block where the fire started. This structure did not burn. The small Carpenter Library, directly across the street from city hall to the east, was incinerated by the fire, an example of the arbitrary nature of the fire's path. Second Street and Pennsylvania Avenue is still the site today of Carpenter Memorial Library. A subscription library also operated in Cle Elum. (CWU.)

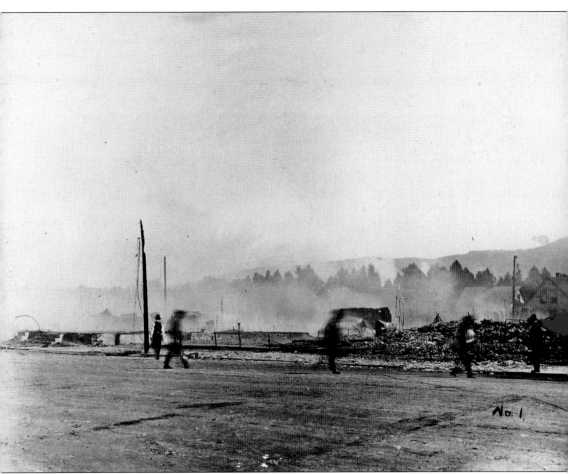

The fire still smolders in this photograph with a view looking southeast down First Street. Because Cle Elum used coal, that smoldering went on for up to two weeks. People could tell where the fullest coal bins were, because once they caught, they did what coal was supposed to do: burn slowly and efficiently. There had been a few close calls on June 25: Jacob Carlson and Andrew Lackman of Roslyn were both injured by being too close to "the explosion of dynamite," as the *Echo* put it, but were not seriously hurt; Frank Albert was hospitalized after being hit by a truck on Second Street during the fire but was expected to make a full recovery. The greatest act of derring-do has to have been Nick Bokavich's rescue of a small child and its mother from an upper story behind Costello & Duffy. He climbed the fire ladder and raced across the roof. The three barely made it out alive. He did not even know the names of the people he rescued. (NKCHS.)

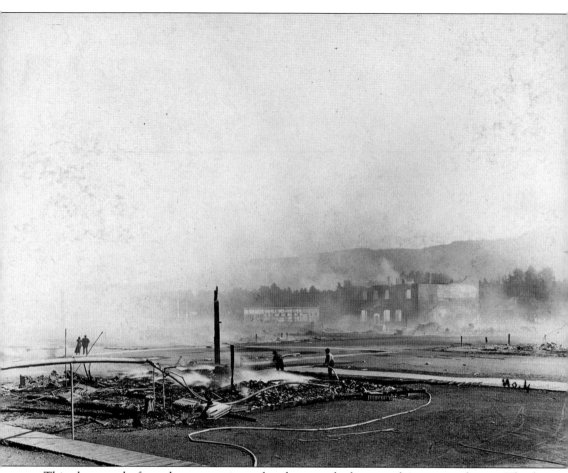

This photograph, from the same series and with a view looking southeast, was taken on Third Street. The fire had taken out both telephone and electric lines, but by the end of the evening of June 25, 1918, at least some power and phone service had been restored. Unfortunately, there were no houses left to run lines to in this area on the north side of Third Street between Wright and Columbia Avenues. (NKCHS.)

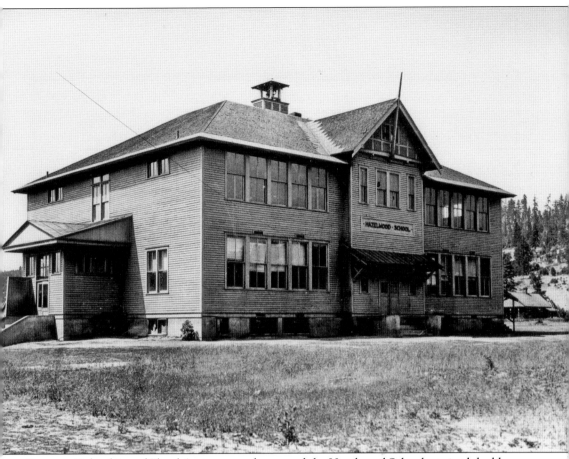

Between Columbia and Floral Avenues, one house and the Hazelwood School survived the blaze. The eight-room Hazelwood School served the east-end children in grades one through eight. After eighth grade, if they desired to attend high school, they walked seven blocks or so to the old Cle Elum High School, officially named Cle Elum Central School. This photograph of the Hazelwood School dates to 1911, the year it opened; it held classes until 1930. (NKCHS.)

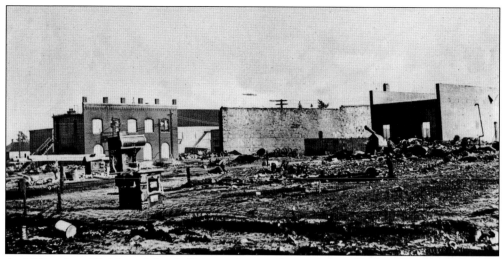

At 4:00 on June 25, Mayor John A. Balmer, along with people from Roslyn, Ellensburg, and Cle Elum, met at the *Echo* offices. They created a crisis committee there and then as so many people needed to be fed and sheltered. Security needed to be maintained around the still-smoldering fire district. Mayor Balmer and his advisors chose not to ask for troops or National Guard assistance, although the Roslyn Drill Squad was armed and patrolled all night. The Sunset Café, still in operation today on the south side of First Street, was designated as the food aid station, and it went to work to serve the newly homeless. The view in this photograph looks from Second Street south to First; the stove may be from the Autorest Café, which opened in a new location shortly after the fire. (Above, CWU; below, NKCT.)

increase of population was neces-
y in order to prevent future starv-
on, the general run of scientists and
licists are of the opinion that the
re population a country has the
er it becomes, and that its wealth,
sperity and grandeur are measured
ely by the number of people with-
ts borders. Consequently the en-
es of the people who interest
mselves in the subject at all are
t toward preserving population,
ce the children's year inaugurated
the department of labor for the
pose of saving the lives of 100,000
dren for the future of the country.
r. F. Truby King, a physician who
had a great deal to do with the
elopment of the New Zealand so-
y for the health of women and chil-
n, was in Washington a short time
and stopped to confer with the
fare experts of the children's bur-
in the department of labor. Dr.
g is on his way to England to take
rge of special work in the English
mpaign for saving the lives of ba-
s and he has visited a number of
es in the United States for the
pose of making inquiry into the
ditions and methods of work in
erican cities.

**Most Could Be Saved.**

I see no essential reason why the
ted States should have an infant
rtality rate twice as high as that of
w Zealand," he told the officials of
children's bureau. "I fancy that
h you, as with us, most of the ba-
s who die could have been saved
proper care. You are losing, as I
derstand it, about one baby in every
under one year old. It is not
ny years since we had in New Zea-
d an infant death rate almost as

ALL WORK GUARANTEED

# Hugg Reopens

We have reopened the Autorest Confectionery and News Stand in the Kinney building on First street originally built for this business two years ago. Finest equipped place in Central Washington.

Ice Cream     Soda Water

Candy     Soft Drinks

Cigars     Light Lunches

Seattle and Tacoma Daily Papers

Cle Elum Echo

## CHAS. E. HUGG, Prop.

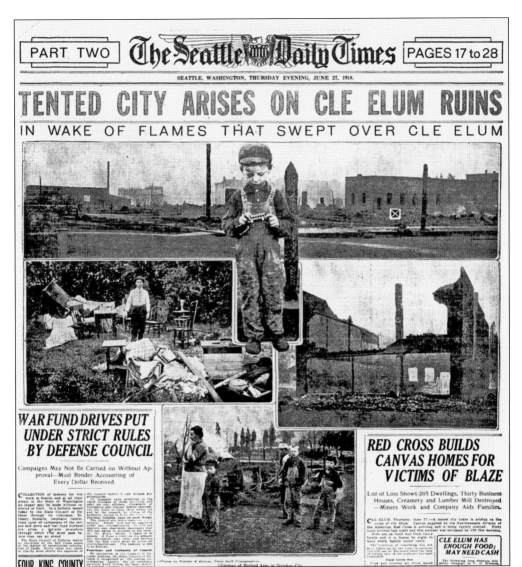

PART TWO | **The Seattle Daily Times** | PAGES 17 to 28

SEATTLE, WASHINGTON, THURSDAY EVENING, JUNE 27, 1918.

# TENTED CITY ARISES ON CLE ELUM RUINS

## IN WAKE OF FLAMES THAT SWEPT OVER CLE ELUM

### WAR FUND DRIVES PUT UNDER STRICT RULES BY DEFENSE COUNCIL

Campaigns May Not Be Carried on Without Approval—Must Render Accounting of Every Dollar Received.

### RED CROSS BUILDS CANVAS HOMES FOR VICTIMS OF BLAZE

List of Loss Shows 205 Dwellings, Thirty Business Houses, Creamery and Lumber Mill Destroyed—Miners Work and Company Aids Families.

Here is a montage of photographs, including one of a stove in the center bottom, from the June 27, 1918, issue of the *Seattle Daily Times*, the issue that scooped the *Echo*. Stoves become a theme in postfire photographs, since they were a central technology in 1918, the centerpiece in both beauty and utility. John Rigek, 19 years old at the time of the fire, remembered his father trying to get the stove out of their house. Intricate metalwork was installed on stoves once inside, and Rigek's father was concerned about harming the ornamentation by bumping it on the way out. (*Seattle Times.*)

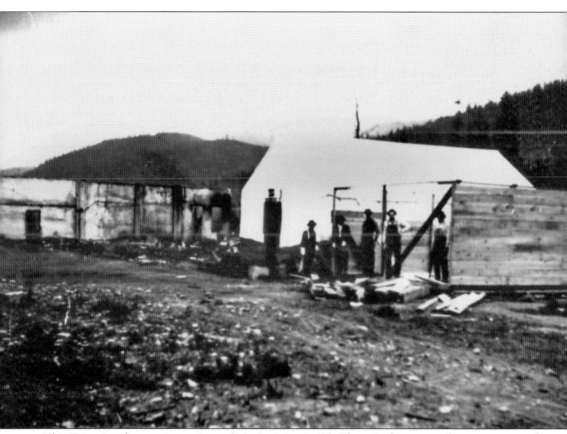

The *Times* article mentions a "tented city" arising in Cle Elum. In fact, more than one group of tents grew to house those residents who had been burned out. The first, engineered by the Red Cross, was on the east side of town, the tents loaned to the Red Cross from recent Jehovah's Witness tent revivals. The Northwest Improvement Company spearheaded another on Hospital Hill on the site of today's city park. These tents had framed floors and electricity and mainly housed the men who worked in the Northwest Improvement Company mines in town. This is the only known photograph of Cle Elum during its tent city days. (EPL.)

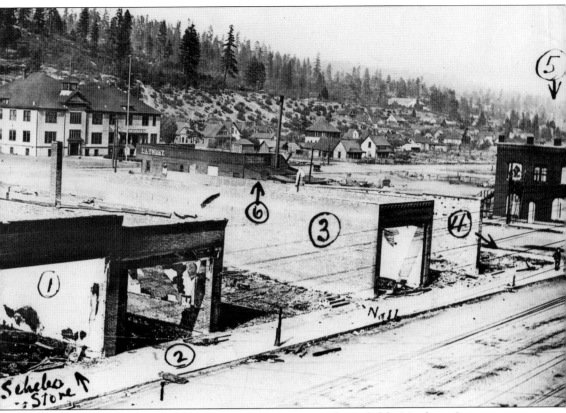

This view of First Street, perhaps taken from the upper story or the roof of the Northwest Improvement Company, was once labeled, but there is no key to go with it. The Cle Elum State Bank, laundry, and Central School stand virtually unharmed in the midst of the destruction. (CWU.)

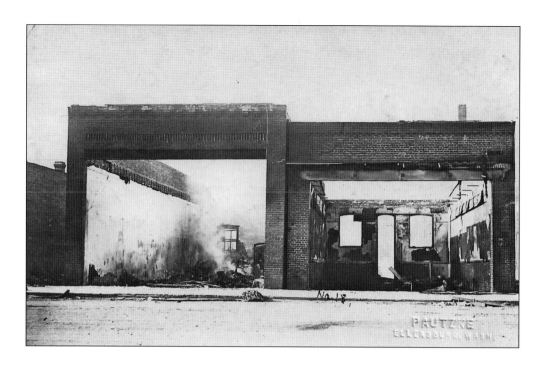

Schele's store, labeled with a "1" on page 73, is described in this anonymous postcard from the time: "This is Scheles store that is still burning every time you went past it you could here the canned goods bursting open." On the south side of First Street, the cracking or breaking of plate glass windows made up the sum total of damage, whereas directly across the street to the north, canned goods popped in the heat. (Both, CWU.)

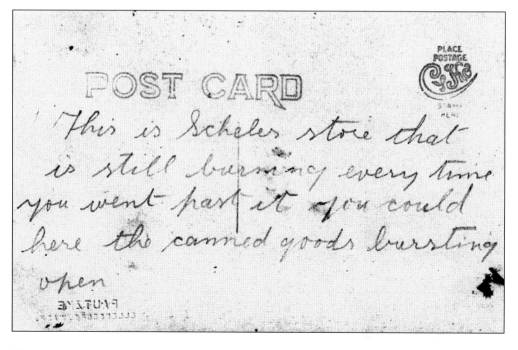

The Masonic lodge
provides some of the
most evocative post-
fire photographs.
Here, a man stands
on the sidewalk
near the shell of the
building. The puddle
in the gutter speaks
of water used in vain
to fight the fire. The
back of the west side
of the lodge reveals
another perspective
of the destruction.
(Right, NKCHS;
below, EPL.)

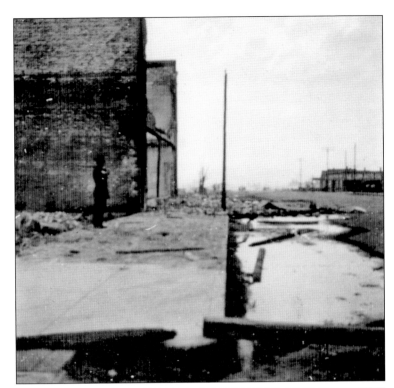

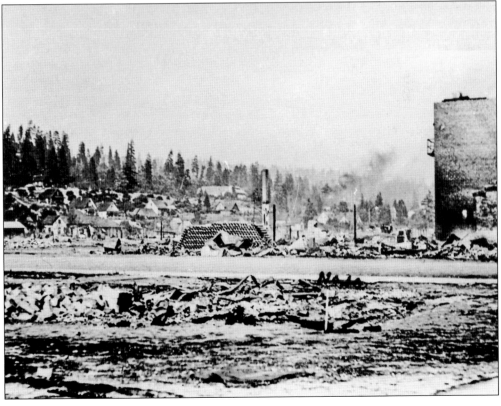

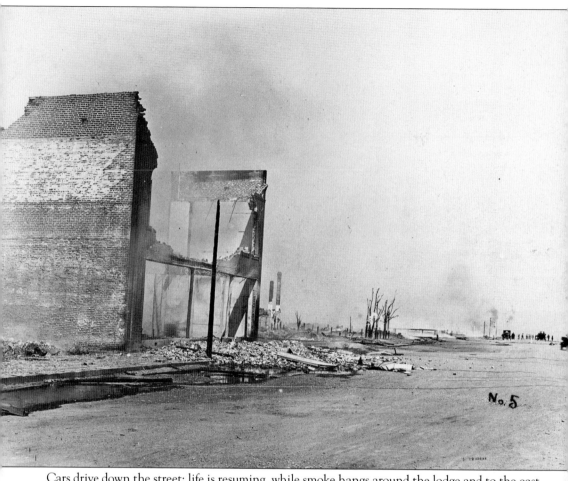

Cars drive down the street; life is resuming, while smoke hangs around the lodge and to the east down First Street. As of July 12, 1918, Haines and Spratt Hardware had erected a shed at the rear of its lot from which to conduct business. The construction of the new hardware building has begun, and an American flag flies from the shed to recognize that this is the first rebuilding project underway. (NKCHS.)

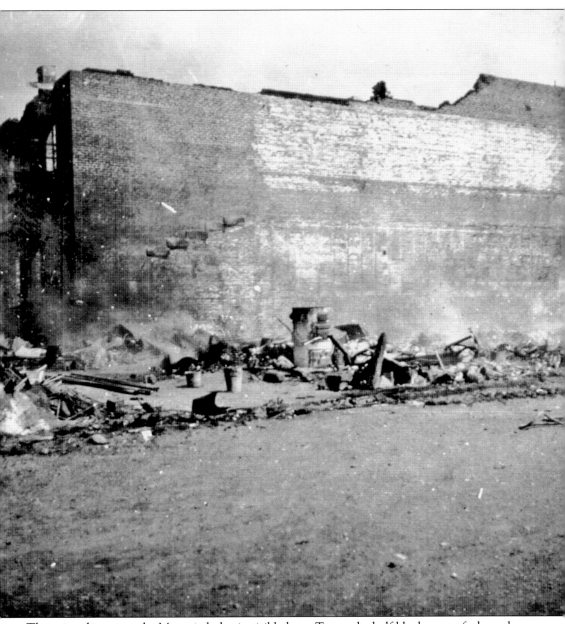

The ruin adjacent to the Masonic lodge is visible here. Two and a half blocks east of where the fire started, the devastation is still complete. In the immediate aftermath, concern existed over the stability of brick walls that remained upright, and the creation of a fireproof town upon rebuilding was top priority, a sentiment echoed in cities across the United States that had gone through major fires. (NKCHS.)

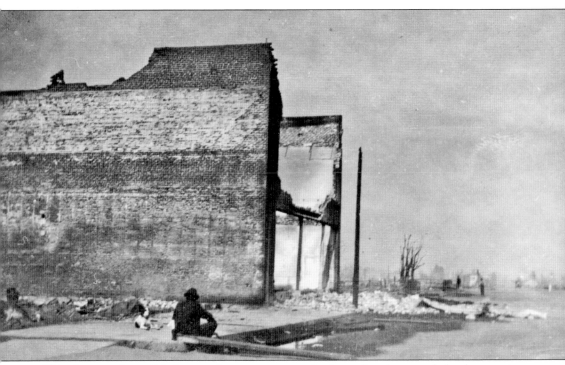

This photograph possibly features the same man seen in the earlier photograph, but he now sits on the sidewalk with a dog and gazes east down First Street or maybe at the lodge. This photograph shows fewer cars, more people on foot, and less smoke, but indicates a stronger sense of desolation and of the weariness that must have come in the fire's aftermath. (NKCHS.)

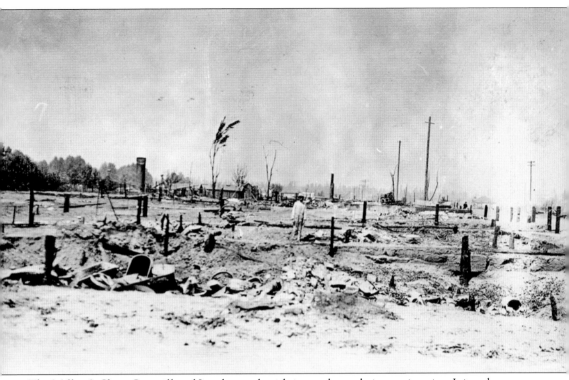

The Miller & Short Sawmill and Lumberyard, with its smokestack, is seen in ruins. It is unknown what the structure is at the rear of the property or who the man standing in the ashes is. It is clear why the *Echo* deemed the yard a complete loss. (NKCHS.)

A week and a half after the fire (according to the July 5, 1918, *Echo*), the town of Hoquiam, on the Washington coast, sent a load of potatoes, flour, and clothing. A July 4 dance in Cle Elum's sister town of Roslyn brought in $150 of relief money to be shared with the stricken town. Immediately after the fire, on June 26, 1918, the Roslyn-Cascade Coal Company had sent $100. Aid continued to come in from all around the region. (CWU.)

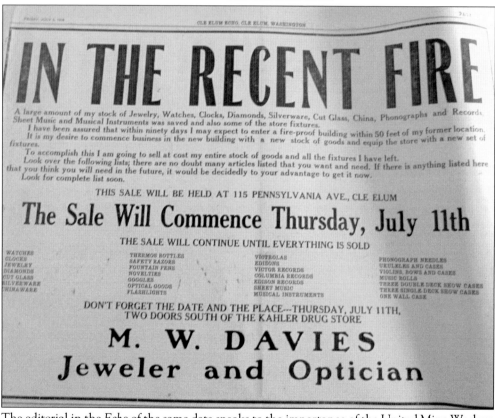

The editorial in the *Echo* of the same date speaks to the importance of the United Mine Workers Union, how strong its national membership is, and its pivotal role in both financial and material assistance. The Northwest Improvement Company had already pledged $2,000 in aid. Merchants were reorganizing and making decisions about their futures. To fund his new store, M.W. Davies, via the *Echo*, invited the public to an actual fire sale. He planned for his new shop to open in 90 days. (NKCT.)

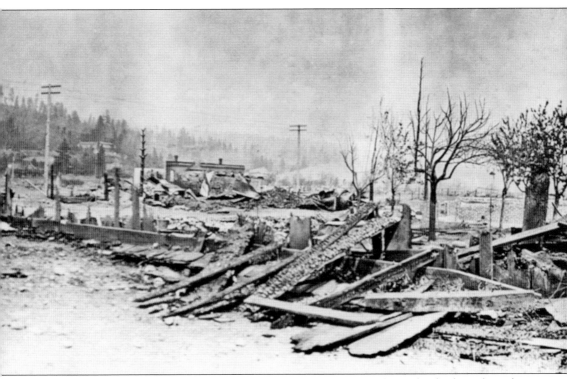

Looking northeast from Second Street, the view in this photograph shows the slag heap from the mine behind the telephone pole on the right. As of July 12, the Schober family was rebuilding its store, as well as what was called the Schober Block, both on First Street. James Lane had bought a total of 75 feet on Pennsylvania Avenue and was set to start work on a new theater to replace the Rose at the place where the fire had started. These plans, along with those of M.P. Kay and the Eagles, would result in the complete rebuilding of the frontage of Pennsylvania Avenue between First and Second Streets, except for the northeast corner lot on First Street. At the same time, glaziers began repairing or replacing the damaged windows on the south side of First Street. (NKCHS.)

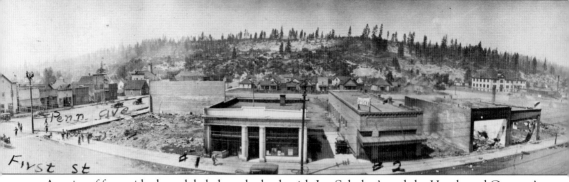

A series of four wide shots, labeled on the back with Joe Schober's and the Hazelwood Grocery's names, now hangs in the Cle Elum Telephone Museum. This one shows the intersection of Pennsylvania Avenue and First Street. A single brick wall still stands on Pennsylvania Avenue near the fire's starting point, one of the walls whose structural integrity caused much concern. The First National Bank building was refurbished and remained in use for some time. The Kinney Building, with its ironic "Smoke" signage, became home to the Autorest Café until it closed in 1975. (NKCHS.)

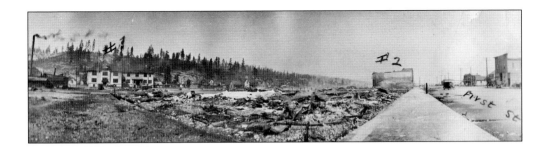

Joe Schober labeled these photographs with grease pencil, so little else needs be said. Because of the Hazelwood Grocery stamp on the back of each, it is possible that the montage hung in the Schobers' store; this speaks to the importance of the fire that destroyed their original building. In that building was the safe from Casland, Washington (pictured below), a lumber town where the forks of the Teanaway River meet. That survived the fire, but its whereabouts are unknown. (Both, NKCHS.)

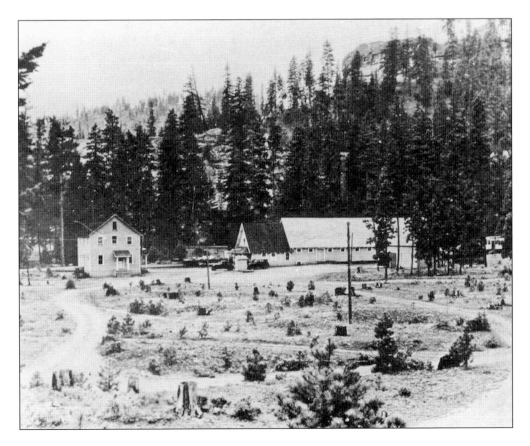

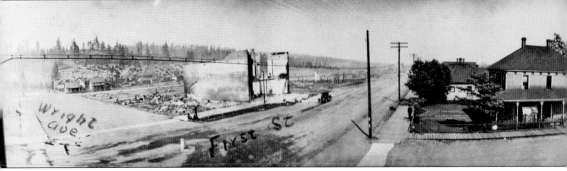

The contrast between the north side of First Street and the south side is especially striking in this picture. The hip-roofed home on the right no longer exists; it was replaced by the local Dairy Queen restaurant. (NKCHS.)

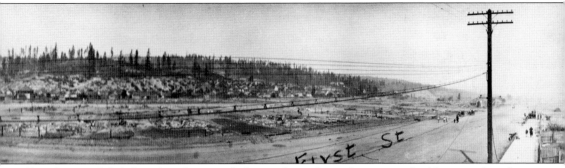

First Street is labeled in this photograph, but nothing else is, because no building stands to be labeled. The view looks north and slightly east at what used to be a town. (NKCHS.)

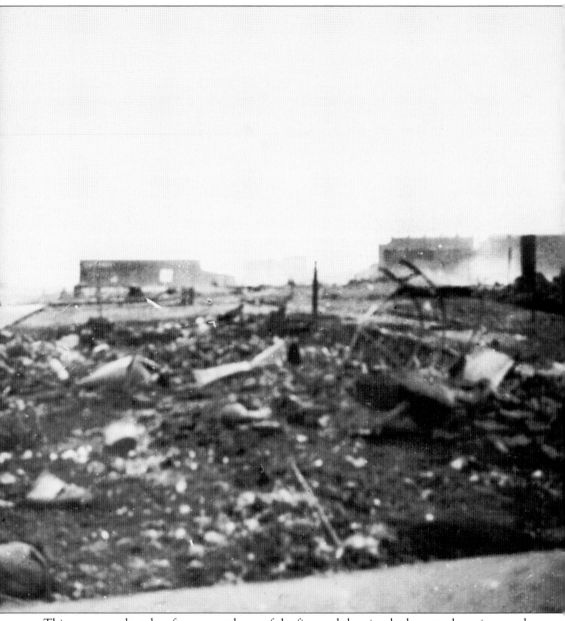

This appears to be taken from ground zero of the fire, and the view looks east; the points on the Cle Elum State Bank's roofline help orient it. The Masonic lodge looms in the center. The Moss family lost a trunk containing Liberty bonds, cash, gold nuggets, and other valuables in the blaze. Some gold and silver were found in the ashes. The Mosses moved into the Reed House in the immediate aftermath. (NKCHS.)

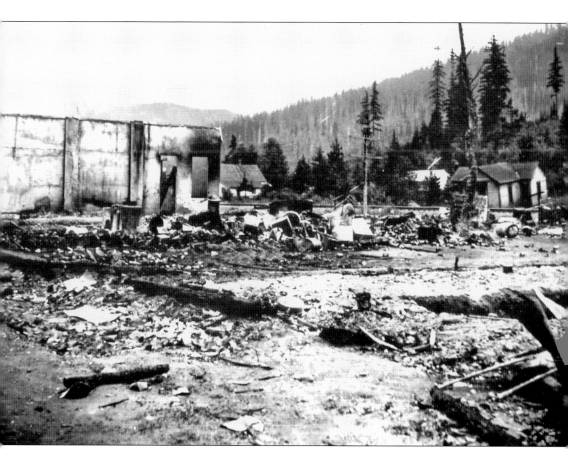

This is one of the few views of the east end of town. The line poles suggest the main Northern Pacific Railroad, with the camera pointed to the southeast, not far from the sawmill. There is, however, a possibility that this shows the spur line that ran north to the Independent Mine, which did not burn. (EPL.)

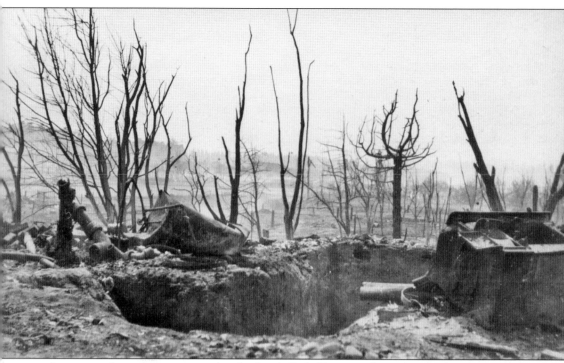

A stove, similar to the one pictured in the *Seattle Daily Times* article on the Cle Elum fire, symbolizes the importance of home and hearth, as well as the losses accrued by so many immigrants, miners, and their families. According to the *Echo*, as of the end of August 1918, the rubble from the Masonic lodge was still being stacked and the walls stabilized and assessed for the possibility of reuse. (CWU.)

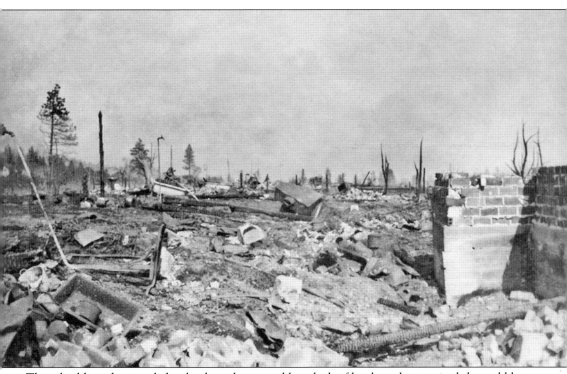

The rebuilding that needed to be done, hampered by a lack of lumber, also required that rubble be sorted through and piled once the area was cool enough to work in. This photograph shows a place where that process has begun. (CWU.)

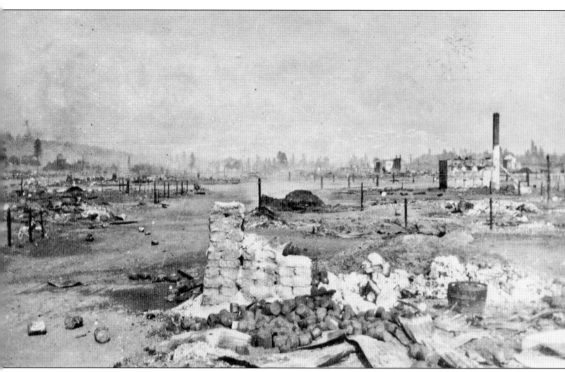

Clear progress has been made, but coal smoke still hangs in the center of the frame. The newsreel producers from *Pathé Weekly News* visited during the first week after the fire and shot some footage, but this precious recording has not been located. Robert Reed, whose creamery bought and processed much of the milk and cream produced in the region, decided to resettle in Centralia, on the coast, creating a vacuum in Cle Elum. Dairy farms shipped their products to Seattle. (CWU.)

On July 12, 1918, the *Echo* reported that rebuilding was well under way. Masons laid bricks and mortar; hammers rang out over seven commercial buildings in the process of reconstruction. The variety store had moved. Mike Miller had received lumber, though an R.R. Short, his partner, decided to throw in the towel and move elsewhere. Costello & Duffy was reopening. The Cle Elum Fire Loan Association was created, and the newspaper urged citizens to invest $100 in shares to defray rebuilding costs. The damage ran to between $750,000 and $1 million, and only 25 percent of that amount was insured overall. Alas, on July 19, the *Echo* announced that the loan association had been dropped due to lack of interest. (Both, NKCT.)

We Have Several Carloads of

# LUMBER

Of all kinds ordered and on hand in our yards here. Place your orders at once and we will serve you as promptly as possible with the satisfaction you have always had from us.

## MIKE MILLER
PIONEER LUMBER DEALER

# Ready for Business

Thanks to the saving of most of our large stock of Men's Furnishings, we are enabled to continue business.

Our store is next the Travelers Hotel building on Pennsylvania avenue ---the brick building---where we shall be pleased to see our old customers and serve new ones.

| | |
|---|---|
| Clothing | Hats, Caps |
| Shirts | Belts |
| Shoes | Ties |
| Underwear, | Collars |
| Furnishings of All Kinds | |

## Costello & Duffy
The home of Hart Schaffner & Marx clothes

Fred Wolfe, formerly day clerk at the Travelers Hotel, was married at Portland, Oregon, last Saturday, Miss Frieda Jenny becoming his bride. They are now living at Ellensburg.

Seth Hannon, who lived at 812 East Third street, lost a fine 16-year old orchard during the fire, one of the oldest if not the oldest orchard in the city. His two-story house burned also.

Leon Erdman, son of Mr. and Mrs. Henry Erdman, is now flying somewhere off the English coast, presumably over the British channel, in the hydroplane service of the American navy. His advancement after he enlisted last October was very rapid and he seems to be a natural aviator. His record in practice bombing was very high and he may be heard from any day in his hunt for German sub marines. Leon will not be 22 years old until next October.

City News was the *Cle Elum Echo's* equivalent of the society pages. Here, in the three issues after the fire (June 28, July 5, and July 12), readers could learn the whereabouts of family and friends; normally, weddings, trips, and even luncheons claimed prominence. Information directly related to the fire is sandwiched in between a wedding and World War I news. Advertisements for Liberty bonds still figured prominently. (Both, NKCT.)

PROTECT THEM

YOU KNOW the fate of the children of Belgium and Northern France.

Protect your own children from a like fate.

Our soldiers are ready to fight for them - - to die for them - - to make the world a fit place for children to live in.

If you can't fight, support those who can.

**Buy Fourth Liberty Bonds**
Any Bank Will Help You

THIS ADVERTISEMENT CONTRIBUTED THROUGH THE PATRIOTIC CO-OPERATION OF

STANDARD OIL COMPANY
O. M. Hoffman, Special Agent, Cle Elum

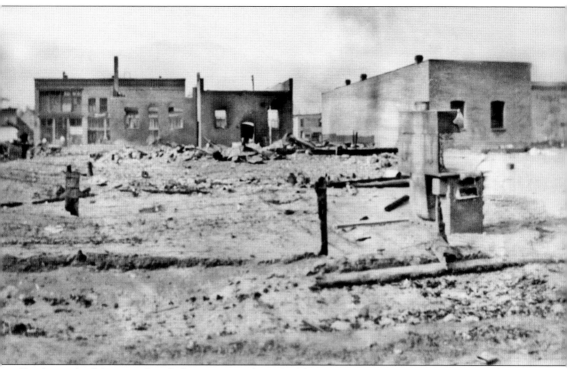

By the end of August, detailed reports on the rebuilding of individual homes and businesses had almost ceased being newsworthy in the *Echo*. The September 27, 1918, headline reads "City Proves It Has Pep to Come Back," and the issue outlines the construction that had taken place. Although some buildings were still roofless, those within the fire district were being constructed with fireproof materials in accordance with the new city ordinance requirements. The article speaks of the difficulty of obtaining materials and labor during wartime. It lauds the spirit of the citizens and expresses hope that the weather gods will continue to smile upon the town, because fall is a true season in Cle Elum and freezing temperatures are not uncommon by early October. (NKCHS.)

This photograph was shot on Second Street; the view looks south to First Street at the same location as in the photograph on the previous page. In the fall of 1918, memory of the smoldering city was still fresh, but optimism prevailed when it came to the town's future. The problem that definitely tamped down fire news was unexpected, given that sanitary conditions had been so good in the tent cities. That problem was Spanish influenza, which struck Cle Elum throughout October and into November as the war was coming to an end. (RRN.)

# THE YEARS SINCE THE FIRE

## EAGLE SCREAMS HERE WHEN THE WAR ENDS

### ECHO GIVES AUTHENTIC NEWS TO THE CITY SHORTLY AFTER MIDNIGHT SUNDAY AND INDEPENDENT MINE WHISTLE STARTS THE CELEBRATION BY PLAYING "YANKEE DOODLE."

## BAND GIVES MIDNIGHT CONCERT DOWN TOWN

### "Marsellaise" Sung by Jim Bertello and Crowd Cheers Famous French National Hymn—Night Turned Into Day by Scores of Noise Making Automobiles and Marching People—All Business Suspended Monday—Street Parade at Two O'Clock Led by the Cle Elum Band—Mines Closed and Everybady Rejoices With the Rest of the Nation—How Roslyn Celebrated.

The First World War ended at 11:00 a.m. on November 11, 1918. A poem of sorts appears in the November 8 issue of the *Echo* with short lines separated by ellipses. The original capitalization and spacing are preserved in what follows. "LITTLE BROWN HANDS . . . As I was walking Down First street The other morning The fire whistle Began to blow Very Vociferously And I noticed A Group of Little fellows Look terror-stricken For they knew What it meant When the old whistle Blew like that One day last summer But that fear Was suddenly Turned to Joy When they heard Some one say, 'Why, boys, The war is over.' Then spontaneously This little group Of baby citizens Began to sing 'The Star-Spangled Banner' And I wondered As I stood there And saw and heard This display Of real patriotism Just what part These little citizens Would some day Play in the Big arena When the eyes Of the world Would be fixed On America Seeking the Guidance of The Star of Civilization In the Great Adjustment Of human affairs." (NKCT.)

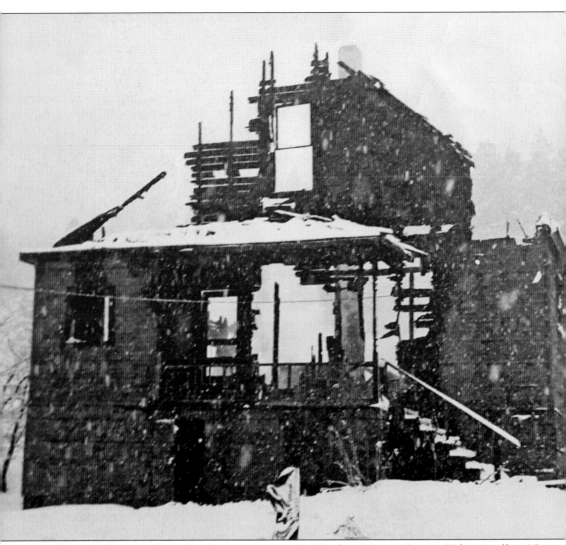

This picture comes from the photo morgue at the *Northern Kittitas County Tribune*'s office. No date or exact location is given, but the image of snow falling on a burned shell lends a sense of what parts of Cle Elum may have looked like as snow arrived towards the end of 1918. (NKCT.)

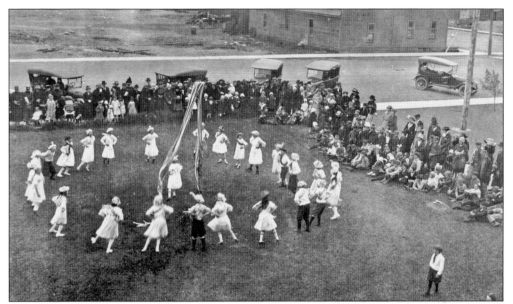

The old Cle Elum High School sat on the north portion of the block, whereas the next building stood farther south. A school pageant is pictured here. The Second Street side of the steam laundry is at the top right of the frame. Traces of the fire can be seen in the empty lot east of the laundry; rebuilding there has not taken place. Archives date this to 1918, but this appears to be a maypole dance. People are bundled up, so either May was cold in 1919 or this is some other activity from the fall of 1918. (NKCHS.)

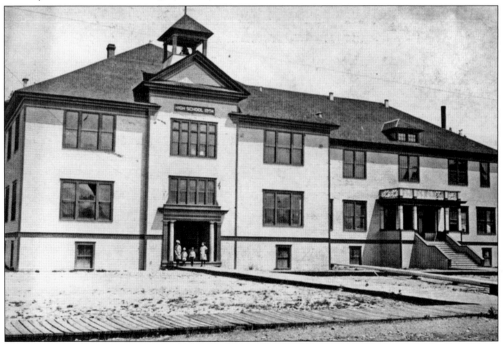

This undated photograph shows the spot on the building's south side where the maypole was placed. Here, along Second Street at Harris Avenue, boardwalks sufficed. The schoolhouse was demolished in the early 1920s. (CWU.)

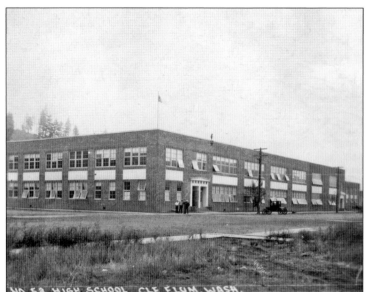

It was replaced by this brick building, which exists to this day. A joint Roslyn–Cle Elum educational complex of elementary, middle, and high schools was built in the early 1970s along Highway 903, which connects the two towns. The conversion of the brick building to condominiums took place not long thereafter. This photograph dates to 1923. (CWU.)

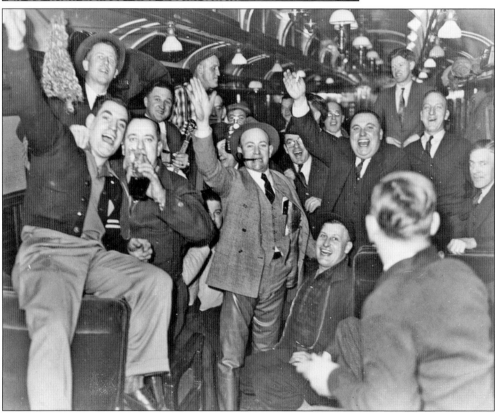

High school athletes in small towns at times have to travel far to get to their contests. Lester, a railroad town across Stampede Pass to the southwest of Cle Elum and now a ghost town, was one such place. In this 1932 photograph, boosters aboard a train have supported the basketball team, which, judging from the smiles on people's faces, must have won. Bruce Ashman, of the Ashman Bar, waves from the center of the photograph, a pipe in his mouth. (CWU.)

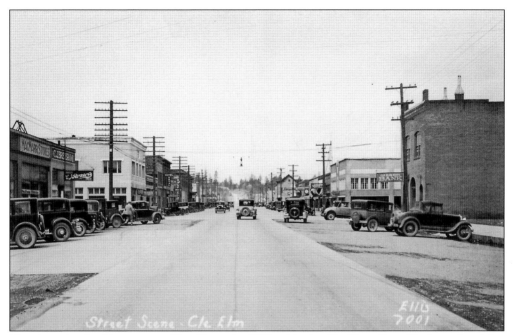

Here is a view looking west on First Street in 1926, with the Cle Elum State Bank on the right. The town appears fully functional and, in fact, was recovering quite well. However, there are clues: one can see space to the east of the bank on the right of the photograph. Only a total of three buildings stood between Harris and Wright Streets on the north side of First Street: the bank, a bakery at the east end of the block, and on the east corner, the telephone exchange. The middle of the block was vacant. The 1940 Sanborn map reveals that, by then, the middle of the block had been filled by a creamery and a garage. (EPL.)

This 1935 photograph taken from Hillcrest directly north of the new school shows the rebuilding of Pennsylvania Avenue, one block to the west of the school, as well as that of First Street. (CWU.)

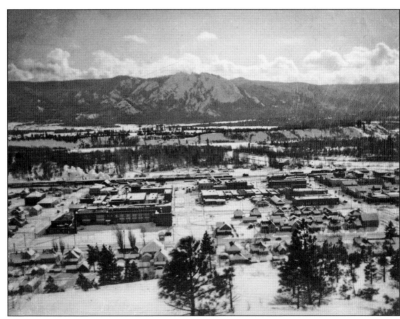

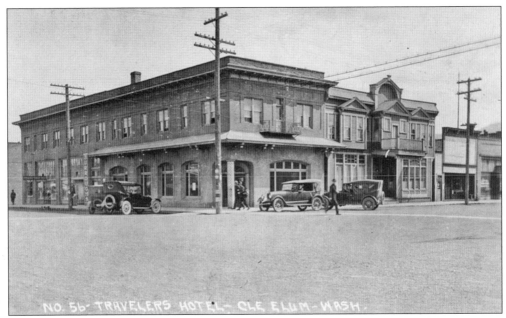

This 1934 postcard shows the Travelers Hotel and the Central Hotel on Pennsylvania Avenue and First Street. Substantial stacking on the telephone poles and the newer cars parked on First Street show the passage of time. The population, though, was dropping. Some estimate that the population before the fire in 1918 was close to 3,500. After the fire, the 1920 census showed 2,661 as the figure, almost 90 less than the 1910 census. The 1930 census shows a drop of 150 people, down to 2,508. (CWU.)

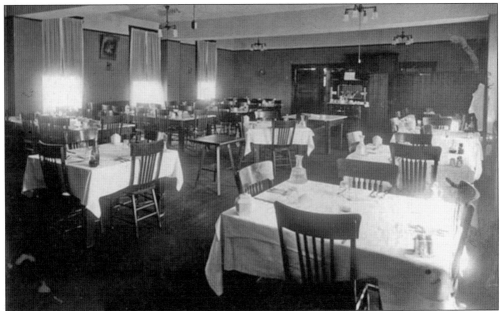

The interior of the Travelers Hotel dining room, complete with white tablecloths, glows in this 1930 photograph. The Travelers burned around 1935, and the Central Hotel was also damaged in the blaze. Both were demolished and were replaced by a gas station that later morphed into an equipment rental business. (CWU.)

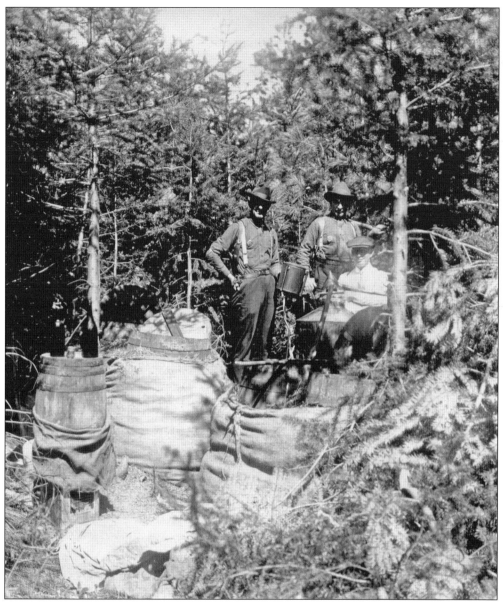

Many Cle Elum households grew or bought fruit and made their own wine. Moonshine, too, was not uncommon, and the 1920s newspaper, now called the *Miner-Echo* after the merger with Roslyn's *Cascade Miner*, featured frequent articles about the revenue officers' sting operations on illegal alcohol production. In 1928, the town of Ronald, two miles west of Roslyn, had its own devastating fire when a still exploded in a hidden chamber under the Falcon Pool and Dance Hall. In this fire, there was one casualty, "Bert" Pellegrino, the dance hall owner. Two unidentified men with badges are pictured with a still in this undated photograph. (NKCHS.)

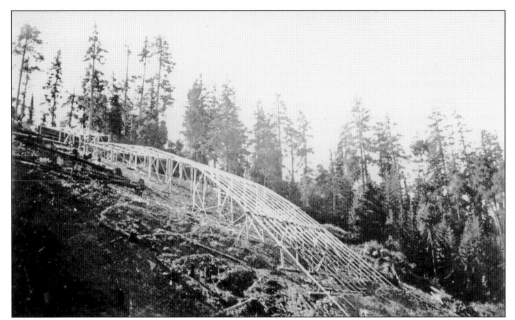

Rebuilding continued, of course, but one development shortly after the fire that represents innovation and high spirits was the establishment of the Cle Elum Ski Club by John "Syke" Bresko, beginning in 1921. First located south of Cle Elum, it later moved two miles north of town. To get there, skiers could avail themselves of one of the Roslyn mine spur lines and go through a tunnel, making the route an adventure. In addition to slopes for downhill skiers and a small lodge, the biggest attraction was the ski jump, seen here under construction. (EPL.)

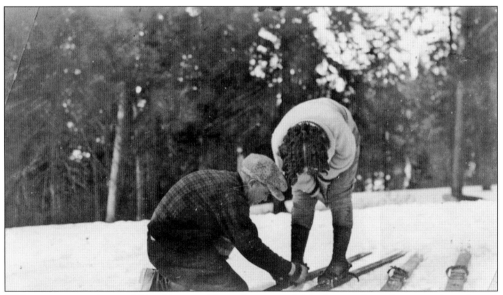

Old-timers remember making skis out of barrel staves, which they took to the steam laundry on Second Street and bent in the warm, moist air. This photograph of Syke Bresko helping a woman with her skis reveals skis with bindings, so these are not the barrel-stave variety. (NKCHS.)

The ski club brought visitors to Cle Elum from all around. They traveled by railroad, since the ski areas that now exist at the summit of Snoqualmie Pass, 25 miles to the west, had not yet been built, and getting across the pass was impossible by car come winter. In 1929, the stock market crashed just as Bresko was trying to develop a new site closer to Highway 10. The ski club failed in the 1930s, a victim of the Great Depression. While it lasted, it hosted carnivals and competitions and even the Pacific Northwest Championship. In 1932, there were 3,200 spectators watching the ski jumping events. (NKCHS.)

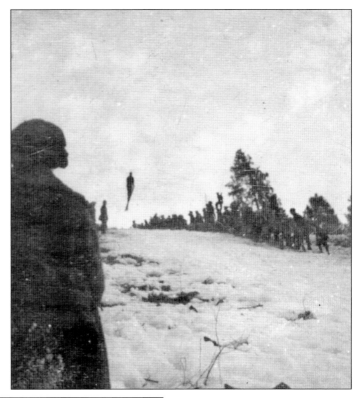

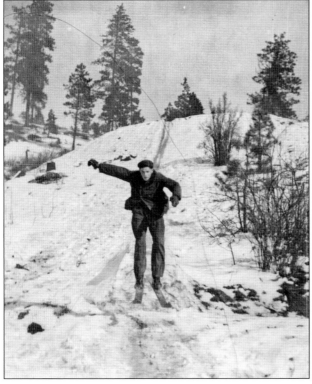

The slag heaps from the local mines provided skiing opportunities. Once the mine was done working the area, local kids also pushed their bikes up to the top of the "camel humps" and rode them down again. This may well be a slag heap or just a local hill. The date is March 26, 1922. (NKCHS.)

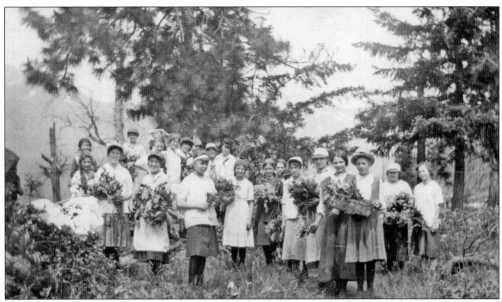

There is no information or date on this photograph, which may be from before the fire, but it illustrates an aspect of Cle Elum life remembered by many people: climbing up the sand rock to the ridge, "going up in the hills." There, one could gather wildflowers—lupine, black-eyed Susans, balsamroot, and wild bachelor's buttons—as these young women did. One could wander or even cross-country ski. Hidden ponds held trout, and shale cave entries revealed fossils of the sea life that once inhabited the area. (NKCHS.)

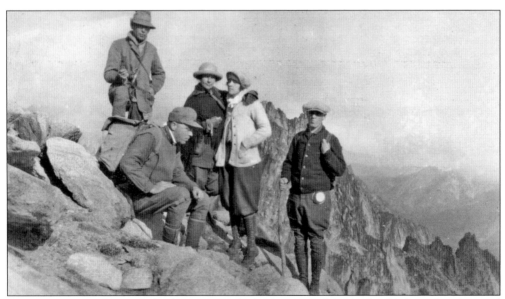

Mount Stuart, northeast of Cle Elum, rises in the background of this undated hiking shot. Pictured are, in no particular order, Bill and Ethel Costello, Syke and Filli Bresko, and Russell Connell. Surrounded by forests and mountains on every side, many people from Cle Elum were outdoorsy before that became popular. (NKCHS.)

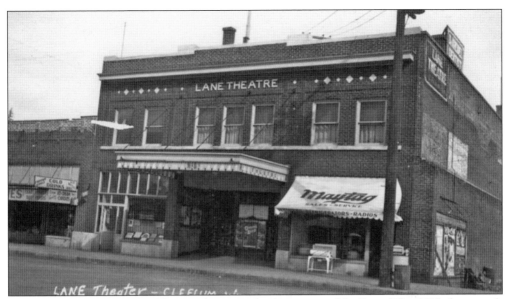

James Lane had vowed to build a new theater at the former site of the Rose. This 1935 photograph shows the Lane Theatre with the Maytag appliance dealer at the south end of the same building. The name of the candy shop to the left is not visible, but ultimately it became the TeePee, which operated well into the 1960s. (CWU.)

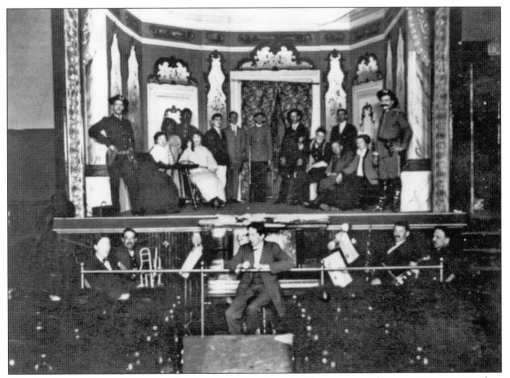

The Lane was the premier performance venue for Cle Elum, not only screening movies but also hosting vaudeville shows. This interior shot from 1925 shows a play that required a pit orchestra. (CWU.)

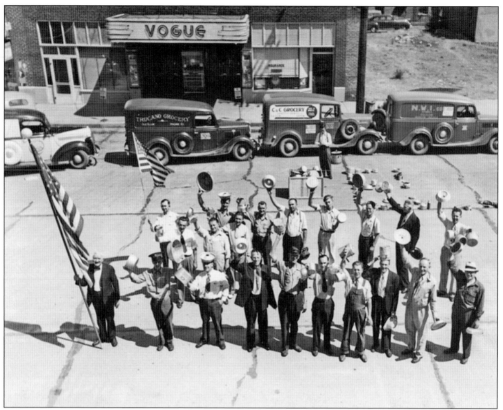

The Lane Theatre evolved into the Vogue Theatre. Why these men are brandishing pots and pans in this 1943 photograph is unknown. (CWU.)

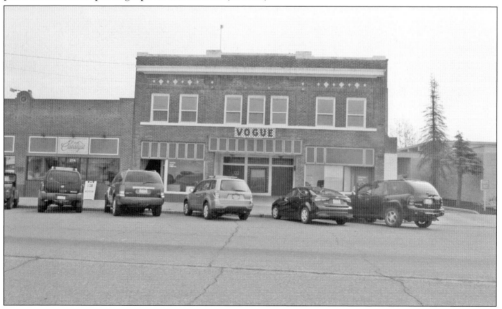

Today, the Vogue sits vacant despite various efforts to renovate it. It has been nominated for the state's Most Endangered Buildings list. (RRN.)

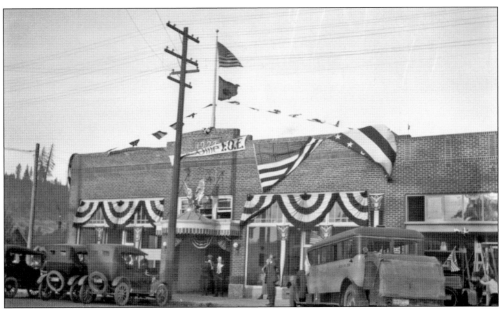

The Cle Elum Eagles aerie was rebuilt on the northeast corner of Pennsylvania Avenue and Second Street as proposed soon after the fire. It was completed in 1923, the same year this photograph was taken. (CWU.)

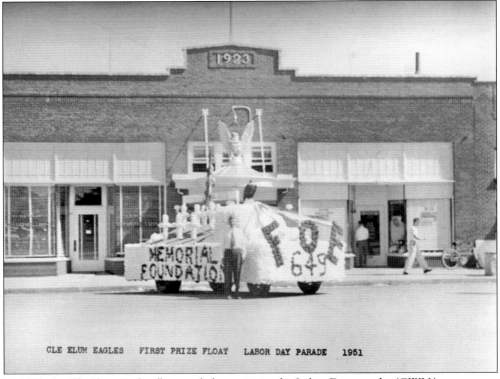

CLE ELUM EAGLES    FIRST PRIZE FLOAT    LABOR DAY PARADE    1951

In 1951, the Cle Elum Eagles float took first prize in the Labor Day parade. (CWU.)

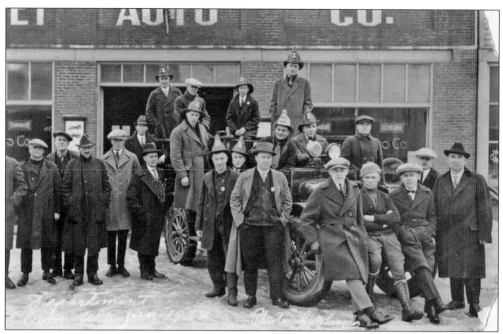

The members of the Cle Elum Fire Department have assembled in 1924, surrounding their vehicle, an early fire engine, which replaced the carts used during the 1918 fire. (CWU.)

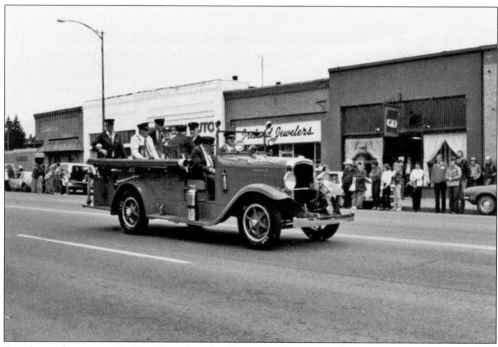

Fast-forwarding to 1982, Cle Elum fire chiefs past and present ride in an antique engine down First Street in the Fourth of July parade. (CWU.)

Here is the fire hall in 2017. This replaced another city hall and fire department in front of which stood a war memorial and two World War II guns. These are now located at the Laurel Hill Cemetery. (RRN.)

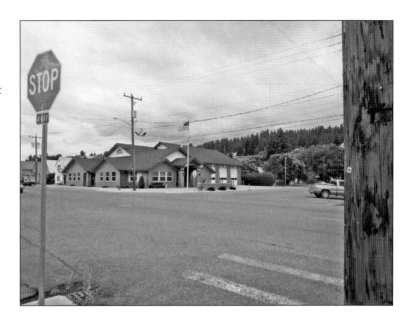

As in 1918, the Carpenter Memorial Library sits across Second Street to the east of the fire department headquarters. The library was part of city hall services until 1978, when the current structure was built. The corner of Second Street and Pennsylvania Avenue sat vacant between the 1918 fire and 1978. (RRN.)

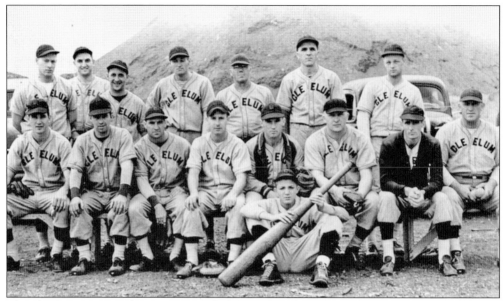

The Cle Elum Rangers, who sometimes called themselves the Cle Elum Clowns (as a self-deprecating joke, according to Ray Kladnik Jr.), played in and around Seattle as well as in the Upper County. The coach was Fr. Ed Weckert, known as "Father Ed," a Catholic priest who had been a member of the Cleveland Brown organization. A fierce rivalry had existed between Cle Elum and Roslyn in the 1930s but had cooled down by the time this photograph was taken in 1946 or 1947 at the sports field on Third Street near the Independent Mine. Later in the 1940s, practices moved to South Cle Elum. (CWU.)

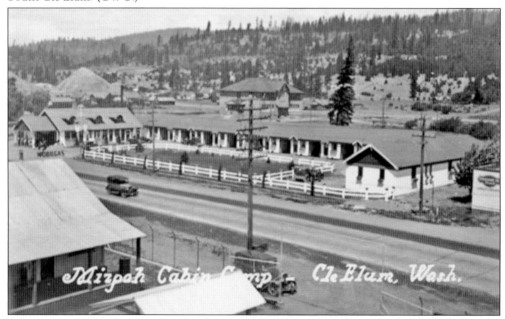

Taken in the 1930s, this photograph of the Mizpah Cabin Camp shows the east end of Cle Elum and its aspect after the fire. Visible in the upper left are the slag heaps from the Independent Mine. The Hazelwood School is the large building just right of center. Neither the Mizpah Cabin Camp nor the school is around today. By 1930, Cle Elum's population had dropped to 2,508. (EPL)

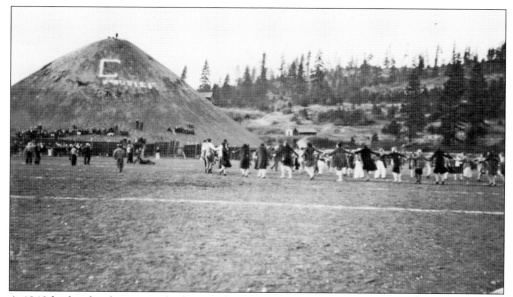

A 1940 high school event took place at the town sports field on the east end; again the camel humps are visible. This is not far from today's location of the Centennial Center, both a senior citizens' center and, in times of wildfires, an evacuation location. In 1940, the population was 2,230. (CWU.)

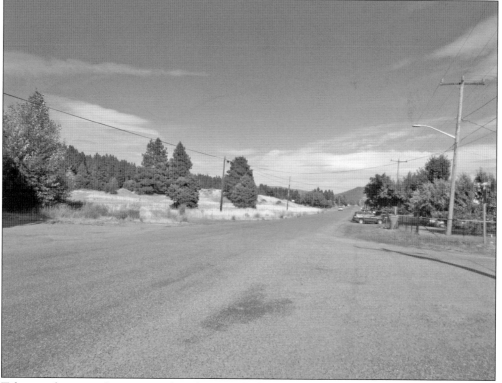

Taken with a view facing east, this photograph shows the same approximate location in 2017. The camel hump has shrunk but is still visible. (RRN.)

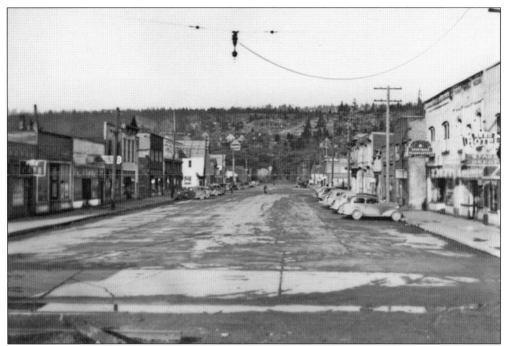

In this view looking north on Pennsylvania Avenue from the railroad tracks, the postfire buildings are on the right in the second block. The Reed Hotel's sign marks the lower right; the "Stage Depot" sign near it harks back to earlier times. However, that sign has been removed in the time between when this photograph and the next were taken. (CWU.)

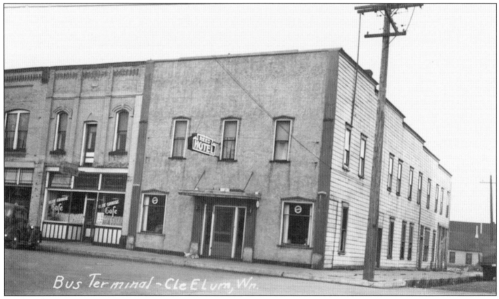

This photograph, from 1940, focuses on the transformed Reed House. The horizontal siding on the south side near the railroad tracks remains, along with the distinctive roofline, but the facade has been rendered much more simple and massive. Brick buildings have replaced the false-fronted structures to the left, or north, of the hotel. This reflects the move towards a fireproof business district so important after 1918. (CWU.)

In 2017, in a view looking north on Pennsylvania Avenue, the bandstand at the foot of the hill is gone and so are the Reed House, the Central Hotel, Joy's Corner, the Northwest Improvement Company building, and the Travelers Hotel, not to mention everything that burned on the east side. The accompanying photograph below dates to 1908. (Above, RRN; below, NKCHS.)

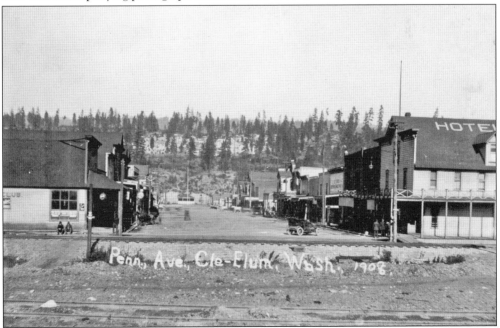

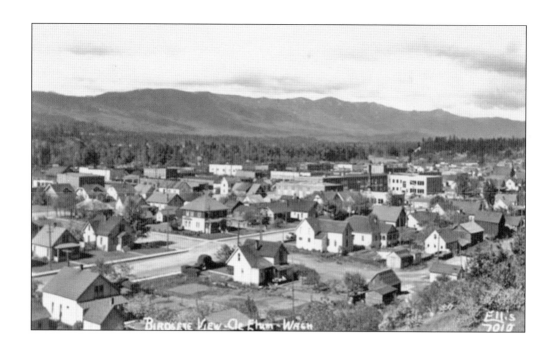

The bird's-eye view above dates to 1941 and shows a town that has recovered from the fire of 1918. It features the new school to the right of center. The Connell photograph below, taken from about the same location, shows the old school before 1923. (Both, CWU.)

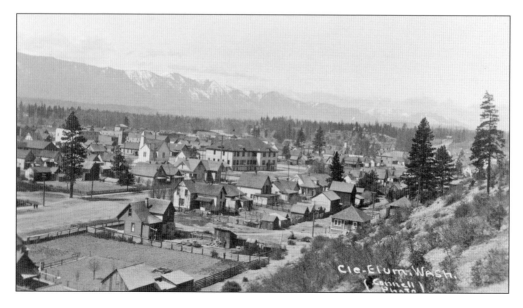

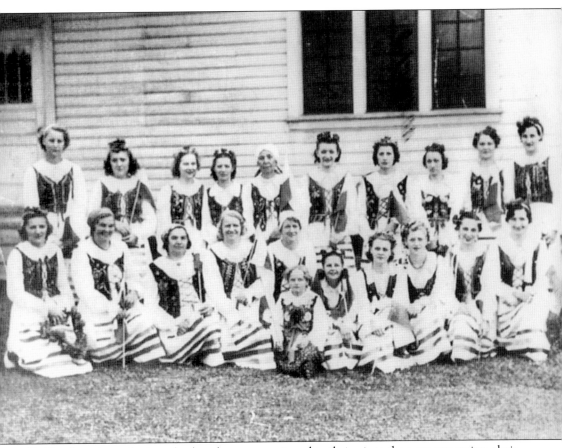

Cle Elum's various ethnic and cultural groups continued to thrive into the next generation, their identities strong and valued. Here, in 1935, is a group of women in Polish dress. Many of them were small children at the time of the fire 17 years previously. (CWU.)

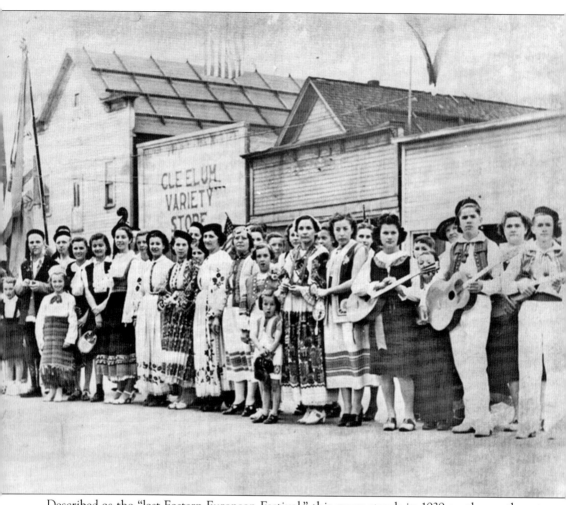

Described as the "last Eastern European Festival," this group stands in 1939 on the northwest corner of First Street and Pennsylvania Avenue, which did not burn. It was known as Joy's Corner, named for a bar and restaurant once situated there. (CWU.)

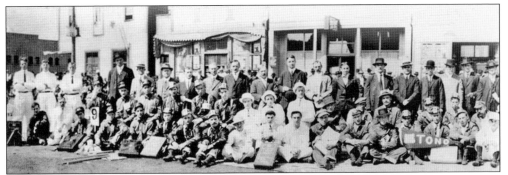

Earlier, in 1920, a group of miners has assembled at Joy's Corner for a photograph. (CWU.)

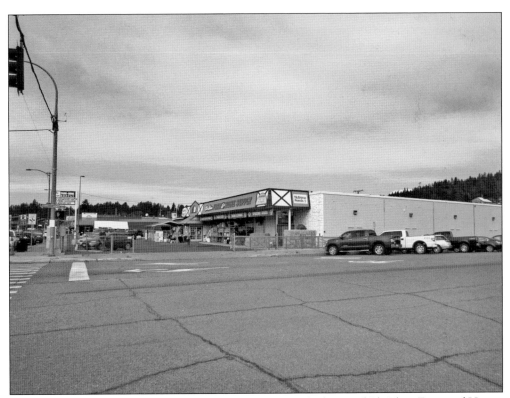

Joy's Corner was replaced by a Safeway store. In 2017, it is the home of Cle Elum Farm and Home. Few people even know this location used to be called Joy's Corner. (RRN.)

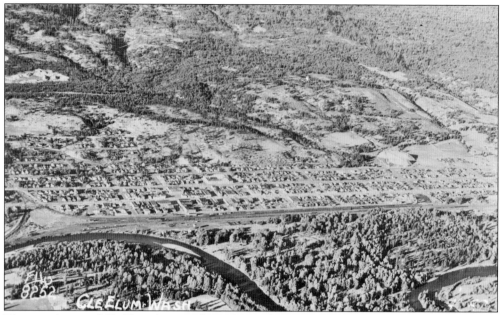

This aerial view of Cle Elum dates to the 1950s. Oakes Avenue is the first street going up to the north in the photograph, to the right of the spur line running to Roslyn. Pennsylvania Avenue is one block to the east of Oakes Avenue. Between First and Second Street on Pennsylvania Avenue, is where the fire broke out. The population had remained almost static at 2,206. (EPL.)

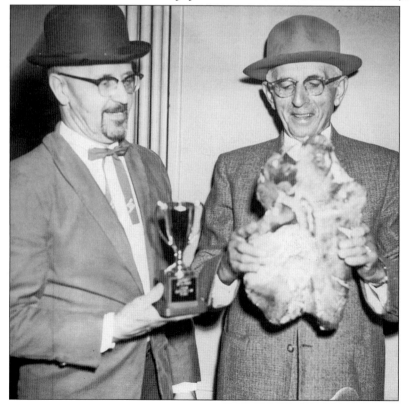

Wild mushrooms abound in the Cle Elum area, and folks will not tell where they found them. The locations of mushroom troves have been passed down through the generations by some families. Here, Peter Fassero awards Barney Moliner with a trophy for having found a giant king boletus in 1955. (CWU.)

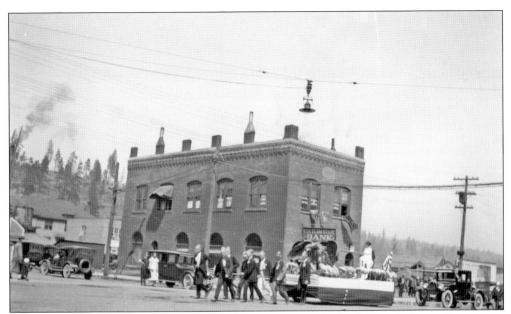

This photograph, dated 1923, still shows the old school in the background. A parade passes in front of the Cle Elum State Bank. Empty lots and rebuilding can be seen to the right. (CWU.)

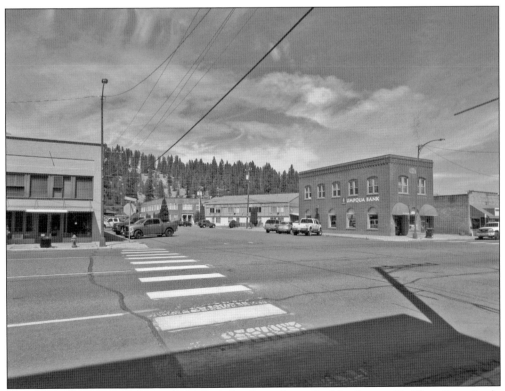

In 2017, the sign for an Umpqua Bank branch adorns the wall of the former Cle Elum State Bank. The steam laundry was replaced by Elumwood, a senior citizens' housing facility. The former high school still stands as well. Now the property to the right of the bank is developed. (RRN.)

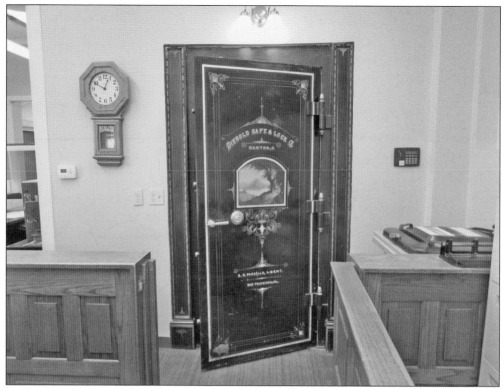

Inside the bank, some of the furnishings are original and date back before the fire. Here are the safe and the teller windows. The light and ceiling fan fixtures appear to be original. The counters are pink marble. (Both, RRN.)

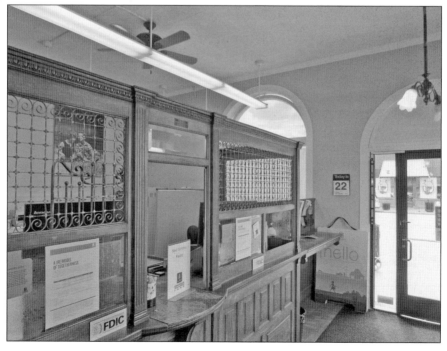

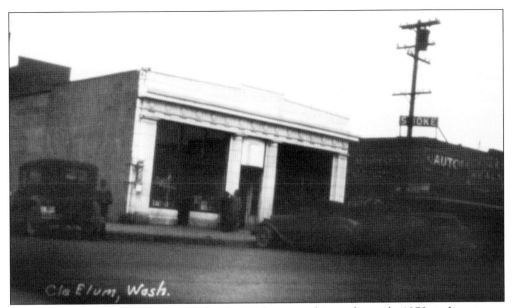

The First National Bank survived the fire and operated into the early 1970s, when it was demolished. (CWU.)

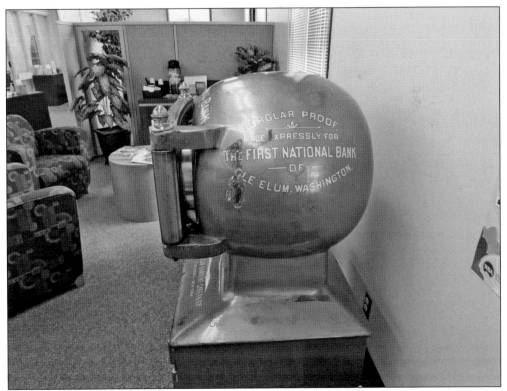

In 2017, the safe from the bank resides in the Washington Federal lobby. (RRN.)

Washington Federal sits on the northeast corner lot on Pennsylvania Avenue and First Street, next to the Vogue Theatre. That lot belonged to the First National Bank. This 2017 photograph shows both the bank and the erstwhile Joy's Corner. (RRN.)

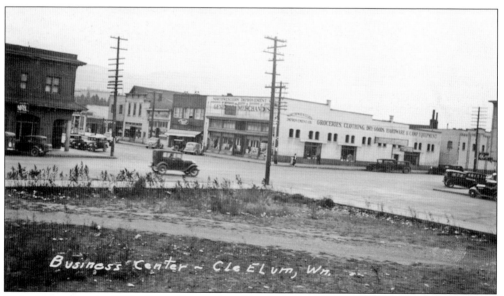

This shot, taken in 1935, shows that corner lot when vacant. It can be seen in some of the photographs before the fire, especially clearly in the photograph of the girls' race (see chapter 1). It remained vacant until 1982, when the Washington Federal building was erected. (CWU.)

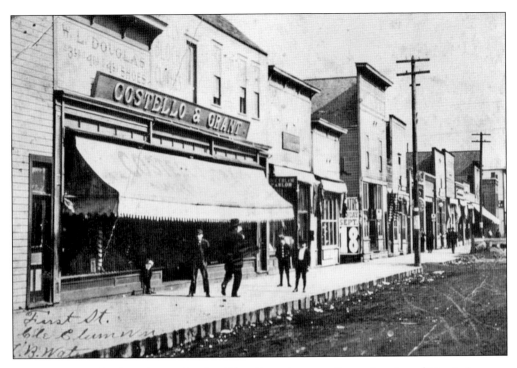

These photographs show the north side of First Street between Pennsylvania and Harris Avenues before the fire and in 2017. (Above, CWU; below, RRN.)

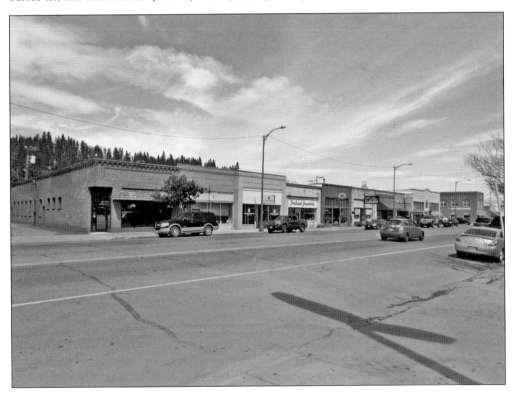

The perpendicular alley in back of the theater between First and Second Streets is accessible in 2017. The rear wall of the Kinney Building still sports advertising signaling the location of the Autorest Café, a ghost of Cle Elum's past. (RRN.)

The fire began here in 1918 in the perpendicular alley. In 2017, the Vogue Theatre wall is on the left, separated from the rear of the Eagles aerie by the Guzzie Building. (RRN.)

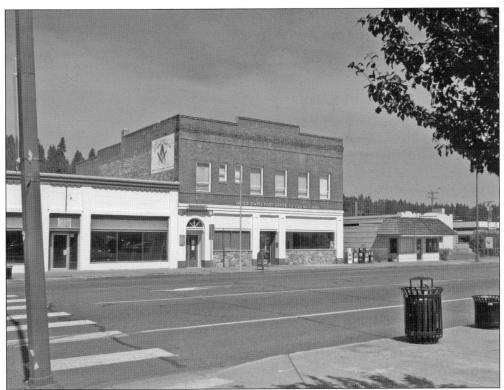

The Masonic lodge, viewed from the Dairy Queen parking lot in 2017 on a sunny day, looks very different than it did just after the fire, although the brickwork is original. (RRN.)

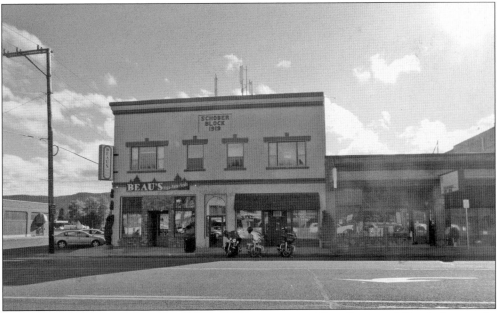

In 2017, the Schober Block stands on the southwest corner of First Street and Harris Avenue. Its 1919 construction date is indicated on the building. Erected at the same time as Schober's rebuilt grocery store, this building was new construction on the south side of First Street. (RRN.)

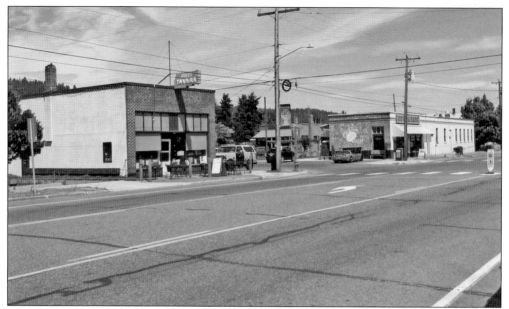

The Cle Elum Bakery still operates from the structure rebuilt by the Pricco family soon after the fire. This is the same intersection where the Hazelwood Grocery could be found. (RRN.)

The site where the Hazelwood School stood has been vacant since the school was demolished. In 2017, plans are in place for the development of this site. (RRN.)

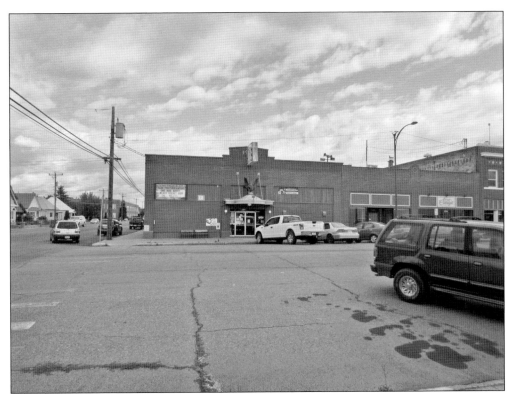

At the Eagles aerie in 2017, the top lines on the sign read, "Thank you, firefighters!" Every summer brings wildfires to the Upper County. (RRN.)

In closing, this familiar view of Pennsylvania Avenue was photographed in 2017 from Hillcrest. It shows a town with mature trees and bushes, Peoh Point rising south of town as it always has, the same place that Russell Connell photographed in the early 20th century. Cle Elum's hardships, victories, and changes whisper quietly across the years. (RRN.)

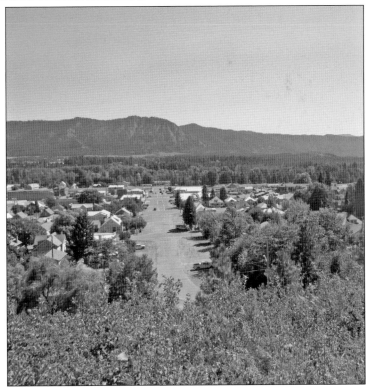

# DISCOVER THOUSANDS OF LOCAL HISTORY BOOKS FEATURING MILLIONS OF VINTAGE IMAGES

Arcadia Publishing, the leading local history publisher in the United States, is committed to making history accessible and meaningful through publishing books that celebrate and preserve the heritage of America's people and places.

Find more books like this at
## www.arcadiapublishing.com

Search for your hometown history, your old stomping grounds, and even your favorite sports team.

Consistent with our mission to preserve history on a local level, this book was printed in South Carolina on American-made paper and manufactured entirely in the United States. Products carrying the accredited Forest Stewardship Council (FSC) label are printed on 100 percent FSC-certified paper.

**MADE IN THE**